Drawing cartoons

Drawing cartoons

Colin Caket

BLANDFORD PRESS
Poole **Dorset**

First published in the U.K. 1982 by
Blandford Press, Link House, West Street,
Poole, Dorset, BH15 1LL.

Distributed in the United States by
Sterling Publishing Co., Inc.,
2 Park Avenue, New York, N.Y. 10016.

Copyright © 1982 Colin Caket

ISBN 0 7137 1181 7

British Library Cataloguing in Publication Data

Caket, Colin
 Drawing cartoons.
 1. Cartooning
 I. Title
 741.5 NC1320

Made and printed in Great Britain by
Purnell and Sons (Book Production) Limited
Paulton, Bristol

Contents

Introduction

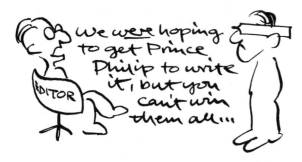

We were hoping to get Prince Philip to write it, but you can't win them all....

EDITOR

Every successful cartoonist, from Walt Disney to Schultz, has thousands of imitators. Plenty of people can draw Mickey Mouse or Snoopy, but they can't call themselves cartoonists, however well they may be able to imitate someone else's style. The real cartoonist draws from life, and from his own inner vision, you can't get it second hand. This doesn't mean that you can't use a few hints, it just means that if all you do is slavishly copy someone else's work you are helping to make them famous, not you. And it means that you won't learn very much. Except about the copyright laws, if you do manage to get something into print.

Cartoonists draw in a wide variety of styles. At first glance there is little in common between the work of any two of them. Look at Thurber and Hoffnung, for example. Very different, but both, in their different styles, draw extremely well. Cartoons are not just an easy alternative to drawing. In my view they are a sort of super drawing.

An artist selects those features of his subject which seem important or unique to him. If, for example, he is making a portrait, he has in his mind a sort of standard face against which he measures the face in front of him. He must understand what is common to all faces so that he can judge what is peculiar to the one he is drawing. Then he must select and emphasise those features to capture the likeness and character of his subject.

This is exactly what a cartoonist does, too!

A caricature is as much a portrait as is a more formal oil painting. When drawing a caricature the cartoonist has to take the process of selection and compression a little further. He has to try a little harder to select the features that are central to his theme, and to exclude everything else a little more severely. There is a distinction between emphasis and exaggeration but this is a distinction the cartoonist should do his best to ignore. The cartoonist has to exaggerate his subject's peculiarities a bit, more than a bit sometimes, but it isn't quite as easy as that. The trick is in being able to choose exactly which peculiarities to exaggerate, and by how much.

Political cartoonists are often asked by their victims for the originals of their most bitterly cruel caricatures. And these caricatures are not then burned, but framed and hung in a place of prominence! Even so, caricatures don't have to be cruel. I once made friends with an Italian student who invited me to his home in a remote little Tuscan hill town. His father was the mayor, and a very important person indeed.

'You are an artist!' everyone exclaimed upon discovering that I was an artist. Or, to be more accurate, an art student. I was on the Commercial Design course at college, a rag-bag tardy students got pushed into when other options were full. The art of portraiture was not included in the course, so this was a daunting assignment. Especially if, as I rightly assumed, I would have all my subject's sisters and his cousins and his aunts peering over my shoulder. But a pencil and paper were thrust into my hand and the mayor struck a heroic pose. I painfully reproduced the rather heavy features and achieved an unfortunate likeness to one of the most dissolute Roman emperors. The more desperately I tried to modify this disturbing trend the more like Nero on an off day my drawing became. Inspiration! I enclosed the noble brow with a laurel wreath. The breathless silence gave way to wild acclaim. I had caught the exact likeness of their beloved mayor! He himself led the satisfied

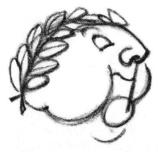

laughter, and went to bring out the grappa. Cartooning isn't always just about big noses; there are subtler qualities to look for.

Let's take an elephant as an easy example. The cartoonist is, of course, looking for those features which make an elephant different from other people — unusual bulk, long nose, excessively prominent teeth, legs like tree trunks, ears which stick out like a taxi with the doors open, more subtle characteristics like a reputation for never forgetting and so on. There's your standard elephant, but you're not drawing just any old elephant! You are looking for a particular aspect of your particular elephant's character or mood. A timid elephant, a bashful elephant, a benign elephant, an elephant who ties knots in his trunk so he won't forget something. There is no limit to the gamut of mood or emotion, to say nothing of physical and intellectual peculiarity, that you can inflict upon your unfortunate jumbo.

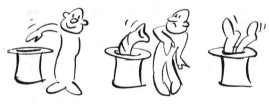

A cartoonist is a magician. He has no trouble pulling even an elephant out of a hat! Or fitting fifteen elephants into a phone booth! Or having an elephant hide behind a golf ball with only his ears giving him away! Cartoons can do impossible things like draw themselves, rub themselves out, lift the corner of the page they are drawn on and walk round it onto the next page, say something, catch hold of the resulting speech balloon by its tail and disappear off the top of the page dangling from it. They can do anything at all, just so long as the cartoonist has the imagination to think of it.

Cartooning is all about having ideas, and the possibilities are endless.

Nothing has to be dull. I was once asked to draw a map of the British Isles as one of the illustrations in a book of statistics. There are specialist cartographers who draw maps, and people called 'chartists' who draw things like bar charts and pie charts. So I assumed that I had been asked to illustrate the thing, rather than these experts, because something different was required. I certainly wasn't about to take on the cartographers on their own ground, anyway! It occurred to me that the most interesting thing about any country to me would be the people in it (if there weren't any elephants, that is). So I made the map out of the people themselves. Not all Englishmen wear pin-stripe trousers or bowler hats, not all Scots are kilted caber tossers, not all Welshmen are singing miners nor are all Irishmen always knocking hell out of each other, but to represent each country simply I had to find a stereotype. What you might call a visual cliché. These are the bread of life to a cartoonist. All desert islands are tiny cones of sand with a single palm tree in the middle, circled by sharks with protruding teeth. All European aristocrats are lean, horse-faced idiots with no chins and protruding teeth. And so on. Cartoonists parody themselves, and given a good cliché a cartoonist should be able to ring the changes for as long as a stand-up comic can come up with variations on 'Waiter, there's a fly in my soup!'

A lot of humour can be wrung from the unlikely juxtaposition of clichés. A primeval fish hauling itself out onto the virgin mud, turning to a more hesitant fish behind it and saying, 'Because that's where the action's gonna be, Baby!' Thurber's vigorous swordsman saying 'Touché!' to the opponent who's head he has just sliced off. Francois' lovely knight in armour standing with one leg bare while he shakes his glasses out of his mailed boot. These are the product of comic inspiration, but humour is where you find it — and you find it everywhere!

In a street occasionally used by the local riding school, someone had parked their Volkswagen with its rear end just over a pile of steaming dung. The juxtaposition was irresistible to me, yet I saw dozens of people walk past without seeming to notice it.

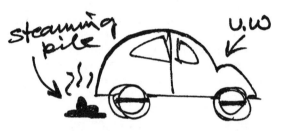

Perhaps the job of the cartoonist is to open people's eyes to the humour around them. But he has to be able to draw to do it. The most basic element of a cartoonist's humour is in the drawing, and it doesn't always come easily. When you are drawing a cartoon, don't be afraid to have several goes at it. Nobody gets it right first time every time. When you look at reproduced work remember you see only the work that the artist finally got right. The difference between an amateur and a professional cartoonist is not necessarily a matter of quality. Nor is it that the amateur draws what he wants to draw while the professional draws what someone else wants him to draw. Nor is it even that the professional gets paid. It is that the professional doesn't expect to get it right first time every time and is prepared to have several goes at it till he does get it right.

So, if your first attempt isn't quite there, don't be discouraged. Draw your characters again and again before you make the final version. Do that again, too, if you're not satisfied, and don't be too easily satisfied! Then expect to have to defend your work. No one is likely to hail it as pure genius, even if it is! Innumerable so-called improvements will be suggested by art directors, editors, advertisers and the proprietor's wife who has just started evening classes in Art Appreciation.

If you are evolving a character for a cartoon strip, or for a book or an advertising campaign, you will have to make dozens of drawings from every angle, covering page after page with them until you know in every detail how your character looks and behaves. The artist who draws for film animation has to produce hundreds of finished drawings in every imaginable phase of movement. So that he can convincingly reproduce movement in his characters such an artist will often study movie film of human and animal movement frame by frame. This is a useful exercise whatever sort of cartoonist you are.

It is not too difficult to analyse movement, but an analysis of humour tends to turn into a post mortem. As someone or other once said, analysing humour is a bit like dissecting a frog: an unfruitful business — especially for the frog!

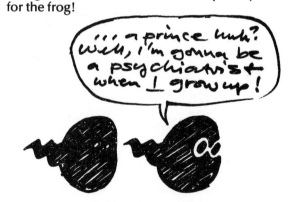

'Caricature,' remarks Freud, 'as is well known, brings about degradation by emphasising in the general impression given by the exalted object a single trait which is comic in itself but was bound to be overlooked so long as it was only perceivable in the general picture. By isolating this, a comic effect can be attained which extends in our memory over the whole object.' This must have flattened a frog or two! Perhaps I should leave humour to the subconscious mind!

But whatever tickles your particular sense of humour — sly wit or belly laugh, the sublime or the ridiculous — your caricatures and your cartoons will improve if your drawing improves. So, taking the easier option, it is drawing I propose to concentrate on here. There is no denying that the cartoonist needs a sense of humour though, if

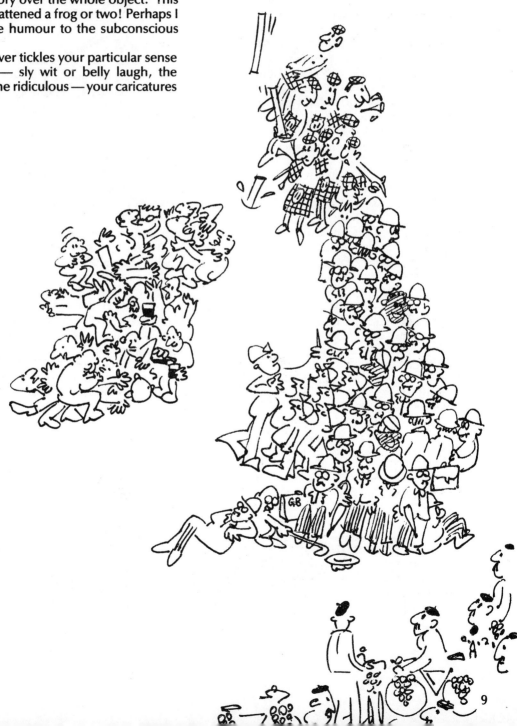

only to help him face the cheques which bounce, the magazines which fold before he is paid and the work which is returned complete with cigarette burns, coffee-cup rings and slips beginning 'Dear Sir or Madam we regret . . .'

The cartoonist shares with the painter the danger of starving to death in a garret. The painter may think that this is all they have in common, and the art establishment regards the cartoonist as a very poor relation at best. Yet cartoons have been produced by artists up to the calibre of Leonardo da Vinci (bigger guns than that there aren't!) and I defy anyone to put down the work of George Grosz, or Ronald Searle's studies of life in a Japanese prison camp, to take more recent examples, as art of an inferior kind. There is no clear dividing line between the cartoon and other forms of visual art. The works of Hokusai, the lithographs of Toulouse-Lautrec and some of Picasso's work have all the elements of the cartoon, except perhaps a punch line! There are plenty of bad cartoonists, of course, but so are there plenty of bad painters!

Cartoons usually communicate ideas directly, dramatically and with wit, but the ideas they attempt to communicate can be very serious indeed. Although cartoons tend to over-simplify complex issues, they are an ideal vehicle for political and social comment. Cartoonists can usually be found rooting for either side in any issue, but at least their weapon is nothing more deadly than humour, a weapon dangerous only to the self-important, the imposter and the fake.

I'd like to put in a word here for the role of the cartoon in education. Nothing would

TEECHER

serve as a better introduction to either representational or abstract art, and nothing would be less likely to bore children! I never knew a pre-school child who didn't love to draw, but many schoolkids learn to loath 'Art'. It might help if art teachers took their subject not less seriously, perhaps, but at least a little more lightheartedly.

This is a very personal book. I make no apology for not telling you how things should be done, but only how I do them. This is not arrogance. On the contrary, it is because I am very conscious that what I write is far from Holy Writ! There are as many ways of drawing cartoons as there are cartoonists drawing them. This book illustrates some of my solutions to some of the problems I encounter in drawing cartoons, with the aim of suggesting ways in which you might tackle similar problems. It does not aim to offer miraculous formulas, nor easy answers. You will get the best results by looking for your own answers, and even your own questions, whether your aim as an aspiring cartoonist is to advance or to avert the revolution, or simply to help fill that awkward pause between the cradle and the grave.

Acknowledgements

To the editors, advertising agents and their clients – in particular Rosemary Canter of Macmillan Children's Book Division, Martin Pick of Belitha Press and Tony Talbot of Working Wood Magazine – who allowed me to reproduce here material originally produced for them, and to Graham Sergeant who put his highly professional camera at my disposal, I would like (pause for breath) to express my gratitude.

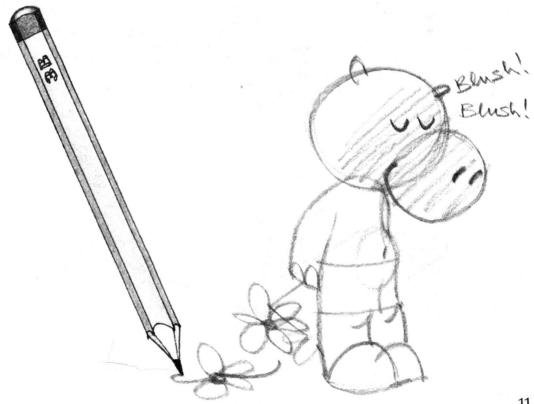

Tools of the trade

Your first requirement will be a <u>large</u> box or bin to throw your rejected drawings in. You have to be your own severest critic!

Because I usually need to have several goes at a drawing, I like to draw on a layout pad of thin, semi-transparent paper. It is cheap enough to throw away in quantity, and I can shove a first attempt under a fresh sheet as a guide for another try.

Abandon hope all ye who enter here!

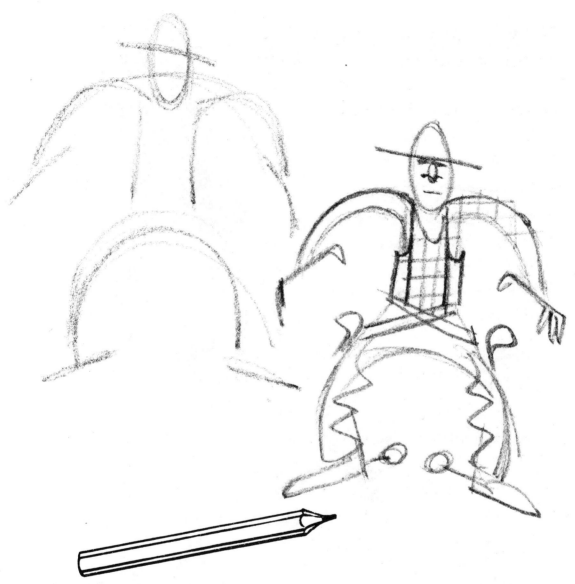

If you draw in pencil you have a chance
to 'feel' for the shapes you want without
committing yourself too quickly.
From soft, free, exploring sweeps of the
pencil, which barely mark the paper, you
can build up a final version. With a
soft india rubber you can erase bits which
don't work and have another go.

But if you are drawing for reproduction you will probably have to make your final version in ink. Pen and ink is an unforgiving medium, and it is at this point that you will probably mess it up!

Going over a finished pencil drawing in ink is fatal. I keep my pencil guide lines very simple so that the ink drawing stays fresh and alive. There's a wide range of nib widths to experiment with.

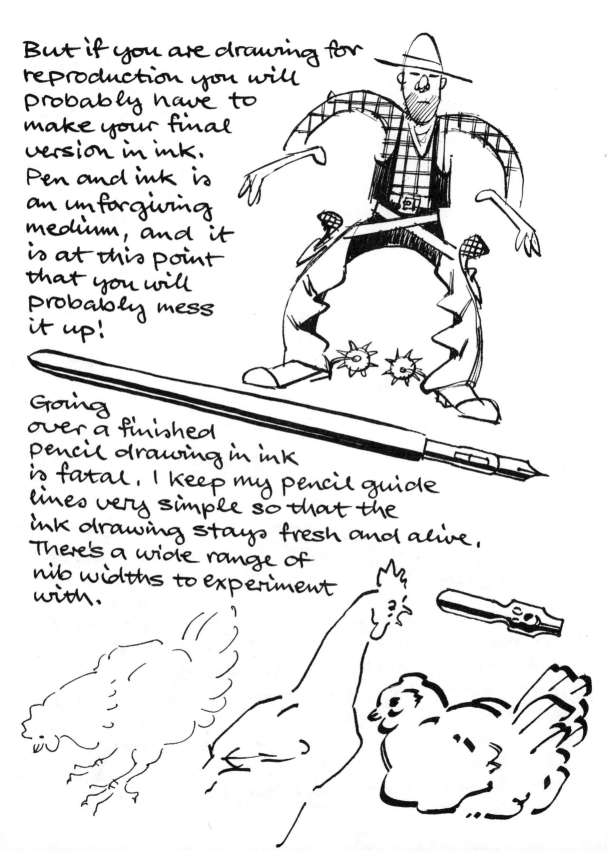

There is also a variety of felt and fibre tipped pens. When I use these I like to make a series of drawings, using each as a guide for the next - rather than lightly sketching the drawing in pencil, as I sometimes do with pen and ink. (Don't use Indian ink on layout paper, by the way, it shrinks as it dries, and the paper goes like crinkly bacon!)

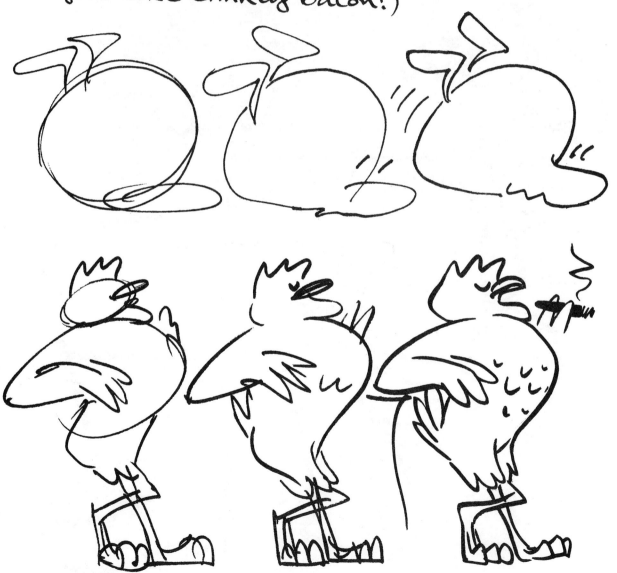

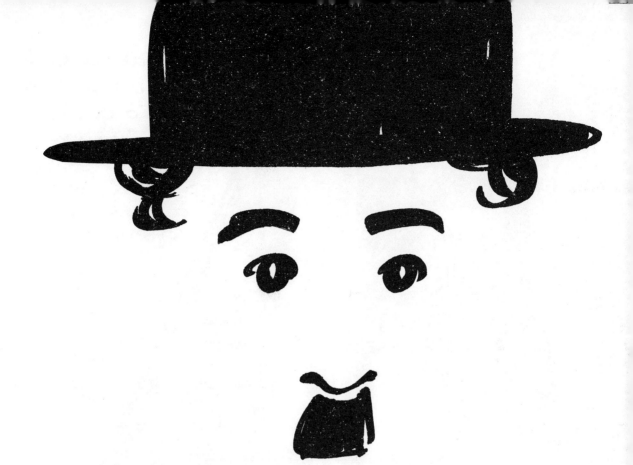

The broader tipped felt pens can give you a line which looks a bit like a hosepipe pushed about with your foot, and if you hesitate you get a blob. But they are good for blocking in big areas very quickly, and effective for drawing with so long as you work freely and on a large scale,

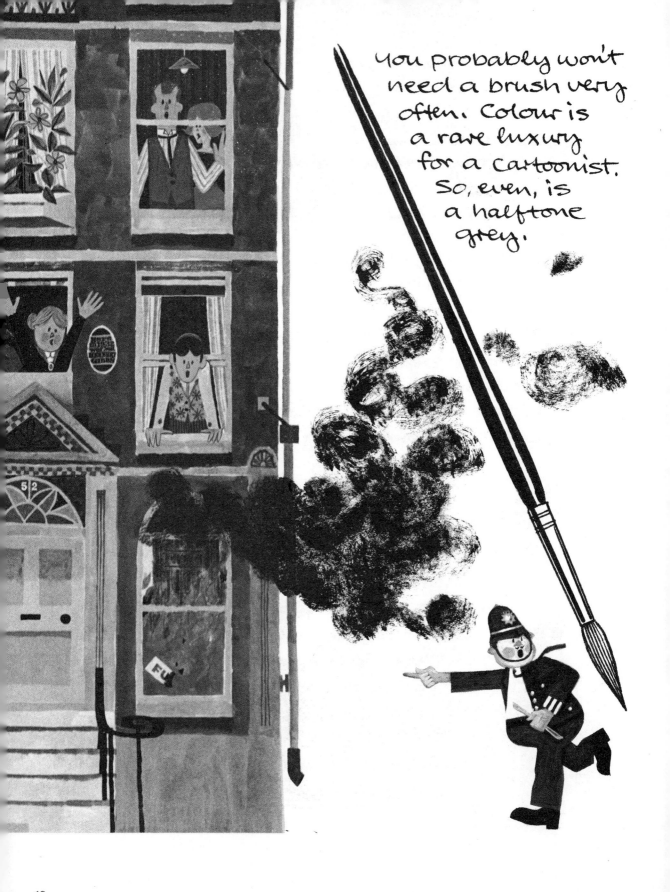

You probably won't need a brush very often. Colour is a rare luxury for a cartoonist. So, even, is a halftone grey.

But if you dip your brush into very thick paint and draw with it you get a broken, textured line known as 'dry brush' (like the smoke here) which will reproduce without recourse to a halftone screen. Or you can simply draw with a brush and ink. You need a brush which comes to a natural point. Test it by drawing it between your lips to moisten it. If it doesn't fall into a natural point it is a rogue brush, and you have probably caught something nasty from one of the many artists who have tried it and rejected it before you!

I like to draw in chalk or charcoal.
Both give a rich, soft line which
will reproduce, like dry brush, without
screening. It's no good fussing
about with tiny details
when you are drawing with
chalk. You need to
draw quickly and freely
— and big!

All the illustrations in this book, except this one ⟶ are reproduced at the size I drew them. I had a feeling it would be cheating not to do this — but it is common practice to draw half up at least.

To reduce the size of these drawings would be cheating only in the sense that my object in this book is to demonstrate as faithfully as possible how I work, rather than to show my work to its best advantage (normally a good idea)! But my feeling, in any case, is that what drawings gain in neatness from reduction, they lose in vigour. Ink drawings made with a fine nib can be improved by <u>increasing</u> the size in reproduction.

It was something I said maybe?

Chalk or pencil drawings will smudge unless you 'fix' them with fixative (which will probably endanger your health if you inhale it, and the ionosphere if you don't). Pencil drawings can look terrific if they are increased in size in reproduction too - and you can make sure you have got them right before you fix them. Increasing the size of a drawing, though, is not always such a good idea when it has been patched and botched up too much!

A craft knife is your weapon of last resort. Not to cut your throat with, but to botch up mistakes in your work. Botching is not to be recommended from the artistic point of view. It can only be employed in work which is intended for reproduction, where the patches don't show. But when your deadline is ten minutes ago, they are holding the front page at a thousand pounds a minute and you have just messed up the left foot, a little surgery with your craft knife is permissible.

This drawing is not one I am especially proud of, and I never did get the feet right...

but I include it as a good example of a
badly botched piece of work.
With the aid of some lighter fuel, to dissolve
the rubber solution, I took it apart again,
revealing the full extent of the patching.
Which surprised me too!
I remove the odd error from a drawing more
often than I actually add a patch to
one, and I don't have too many days
quite as bad as this! But when
you are having a bad day
it might help to
remember
that we all
have them!

(Portrait of the artist on a very bad day!)

Just to prove it does happen, I got this one right first time! I'm glad it happens, because even though a botched up job looks O.K. on the printed page, it doesn't look so good to the man who signs your cheque!

Presentation matters too. At least stick your work neatly onto a bit of board and fix a flap of coloured card over it. When you succeed people will queue up to buy your doodles on the back of an old envelope. Until then, like me, flatten out envelopes to practice on. Your chance of getting it right first time improves with practice...

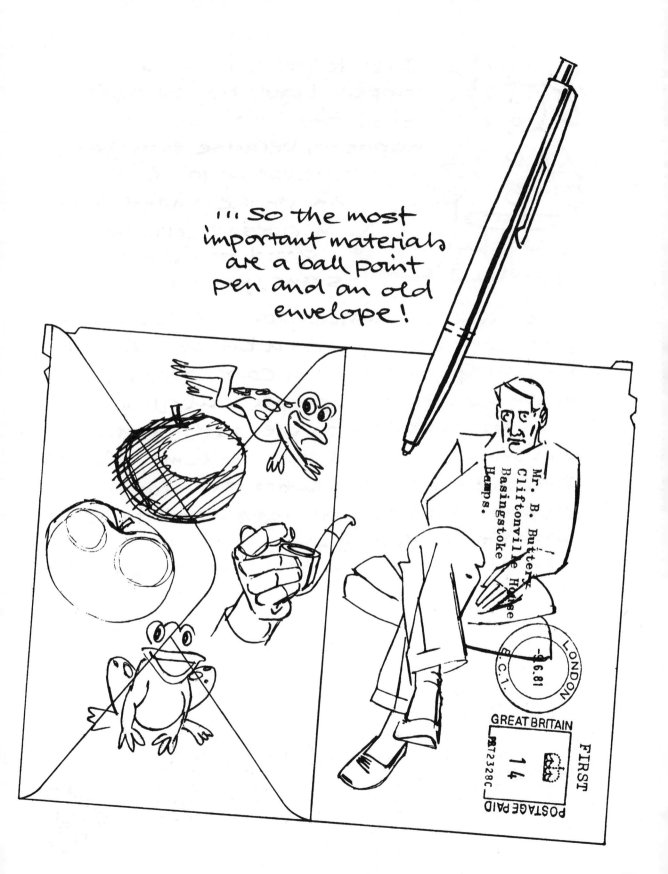

Anthropomorphism

This is just a long word for lending other things human attributes. Like putting a face on a vegetable marrow, or animating a grape.

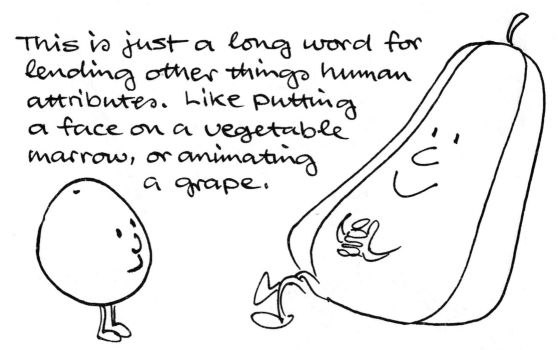

You don't even have to put faces on animals! All you need to do is to put them into human attitudes, or you can put them into clothes like people too.

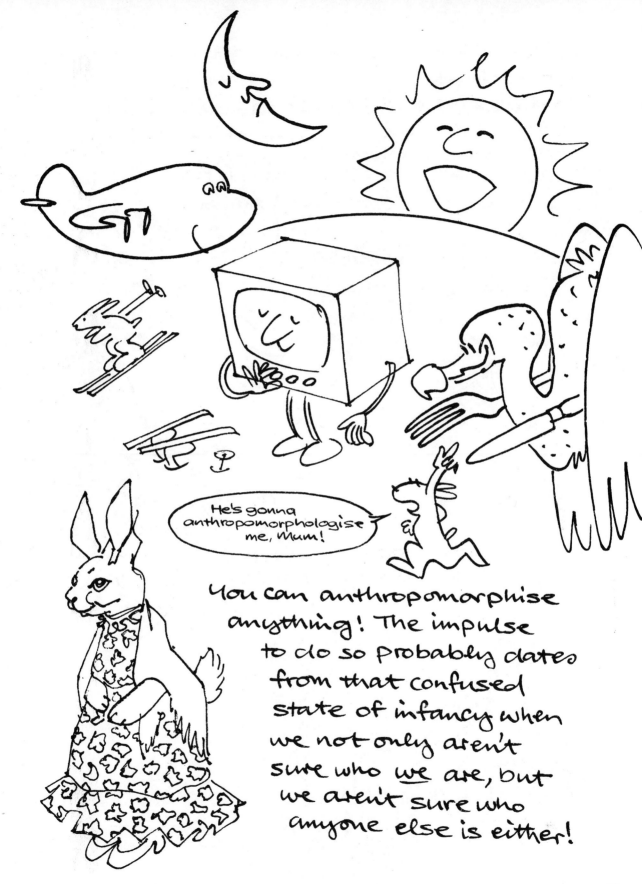

He's gonna anthropomorphologise me, Mum!

You can anthropomorphise anything! The impulse to do so probably dates from that confused state of infancy when we not only aren't sure who _we_ are, but we aren't sure who anyone else is either!

It dates from the infancy of the race too. The Ancients seem to have been pretty confused about who was what, and they dished up a fine line in mythical beings, anthropomorphologised or otherwise!

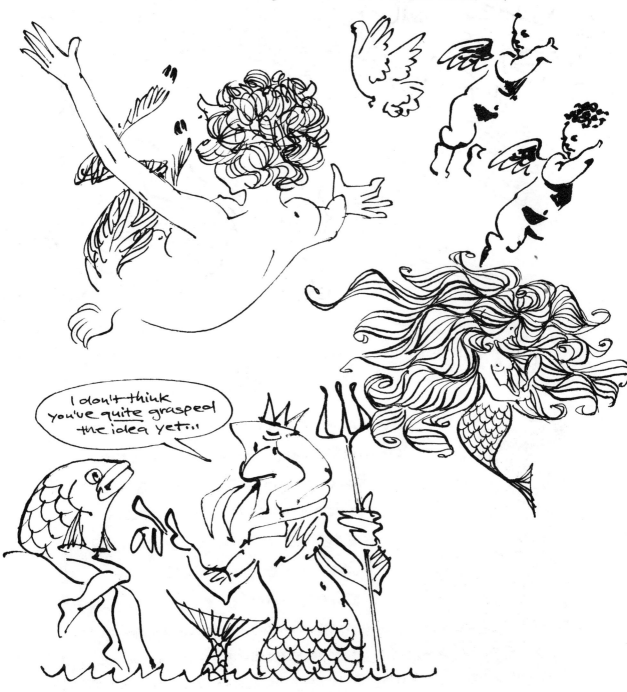

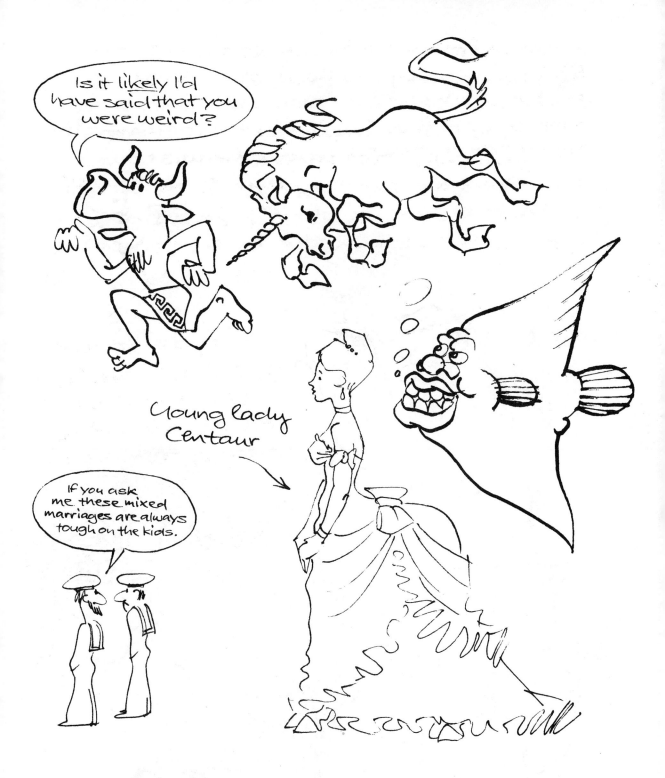

The real point is that if you are going to mix up animals and people in your cartoons, it helps if you can draw both!

Structure

If you want to draw people or animals (or anything else) you need to know how they are put together. Don't bother with the surface details until you really understand the basic structure.

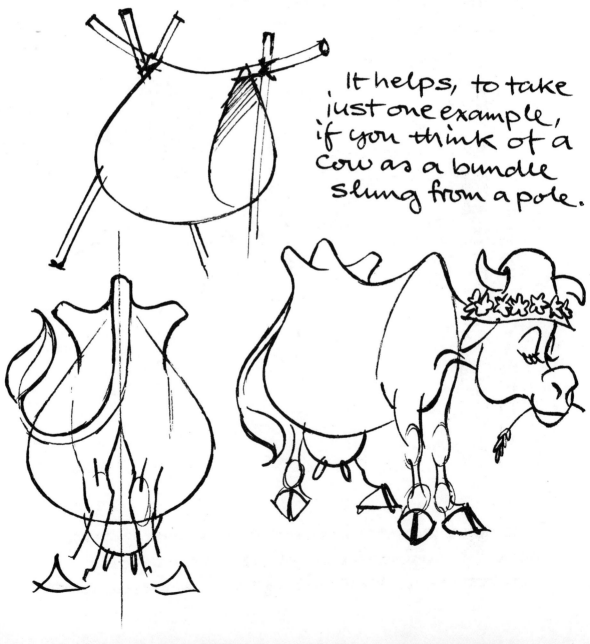

It helps, to take just one example, if you think of a cow as a bundle slung from a pole.

Once you get the structure right, all you need to do is to exaggerate some parts in relation to others. There's a bonus too – if you understand how things are put together, you understand how they move!

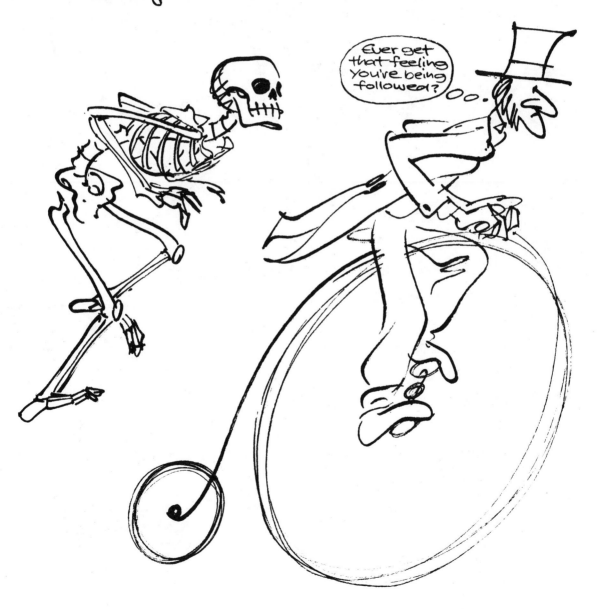

Movement

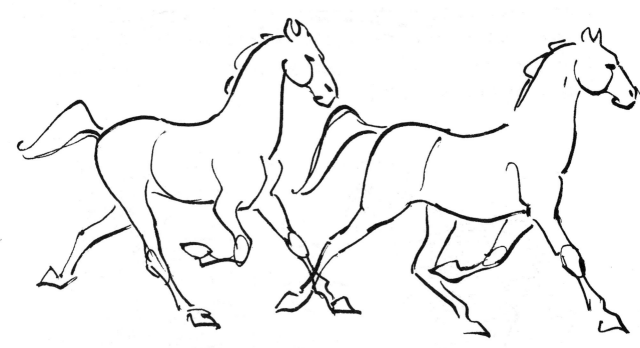

Most four-legged animals trot
with their opposite front
and hind legs
moving together.
In a canter or
in a gallop the
hind legs and
the front legs work
more as a pair, and
the back flexes more.

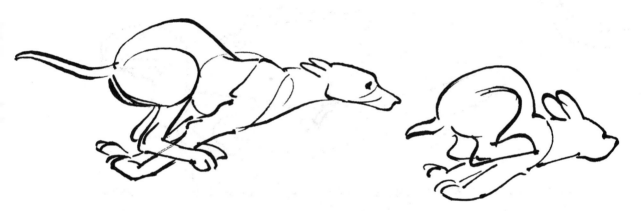

When they are in a real hurry the hind legs appear to be trying to overtake the front legs! Followed by a stretch which can only be described as 'flat-out'!

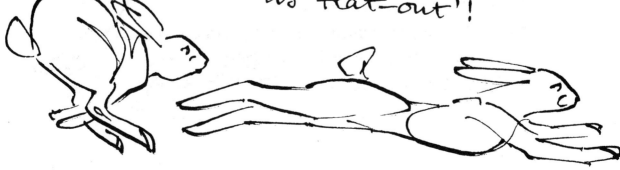

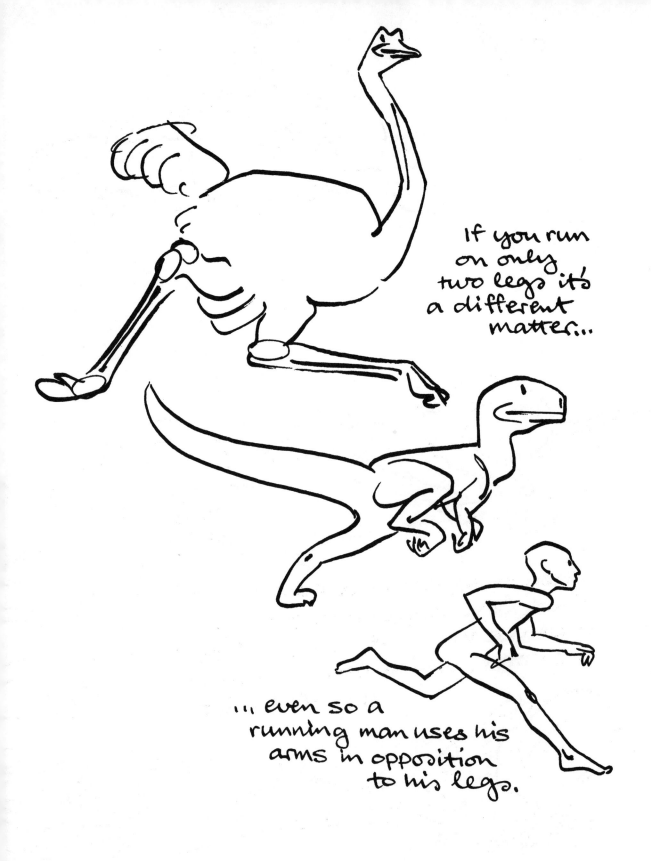

If you run on only two legs it's a different matter...

... even so a running man uses his arms in opposition to his legs.

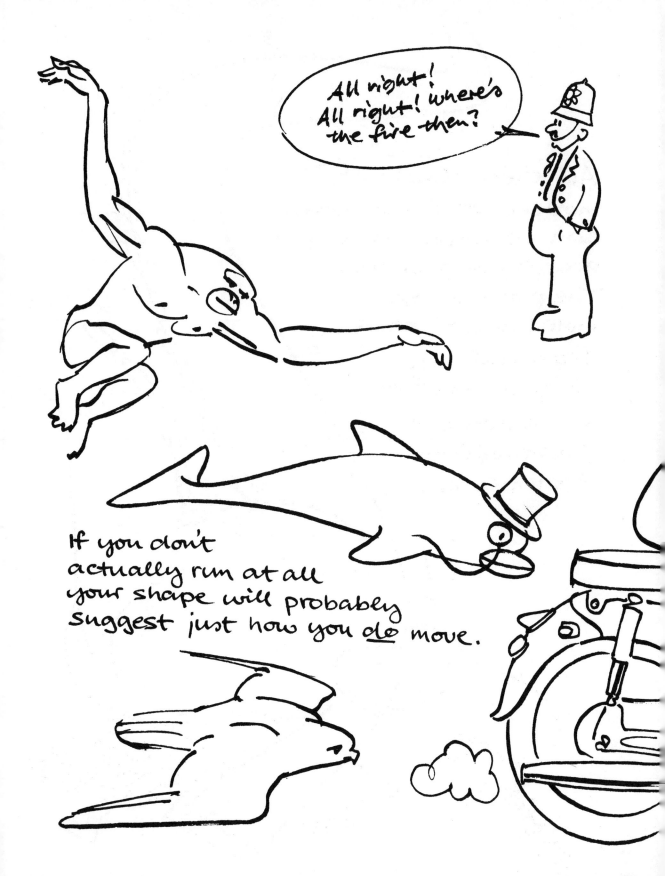

If you don't actually run at all your shape will probably suggest just how you _do_ move.

All these kinds of
movement (and more)
can be used when you
are drawing cartoons.
The point is that
you have to start
from real life.
If you want to
draw someone
skating, for
example ...

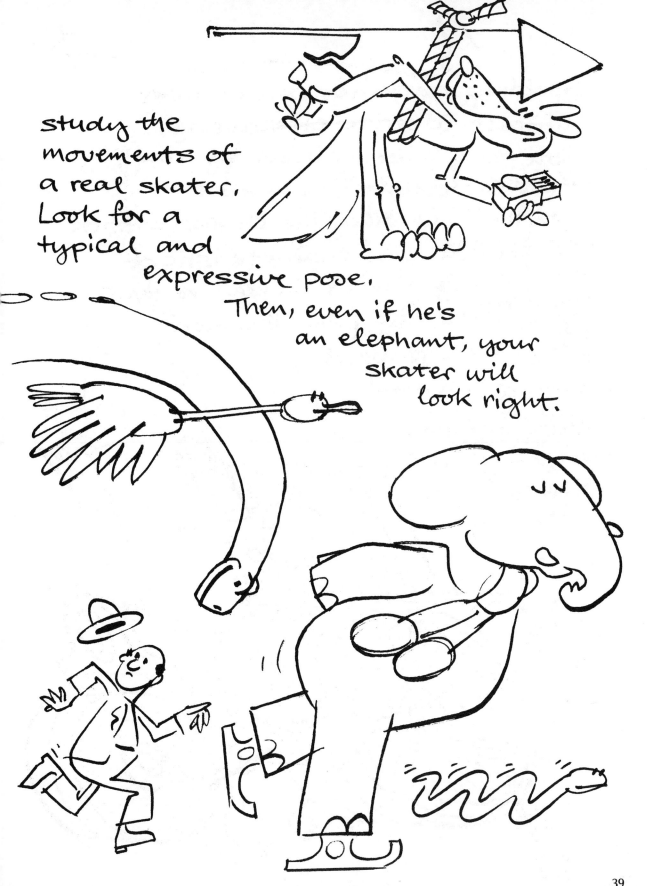

study the
movements of
a real skater.
Look for a
typical and
expressive pose.
Then, even if he's
an elephant, your
skater will
look right.

Speeding machines can be more difficult to draw effectively. You may have noticed by now that cartooning can involve lending one thing the characteristics of another. One characteristic of a running man or animal is that the faster they go, the more they lean forward.

So if you want to draw a machine which is in a hurry...

make it lean forward a bit too! It's also worth including a little independent evidence. The swaying bucket on the steam roller, for example, wouldn't be swaying if the steam roller wasn't rolling. And for machine, man or tortoise, a few 'speed lines' can help suggest motion.

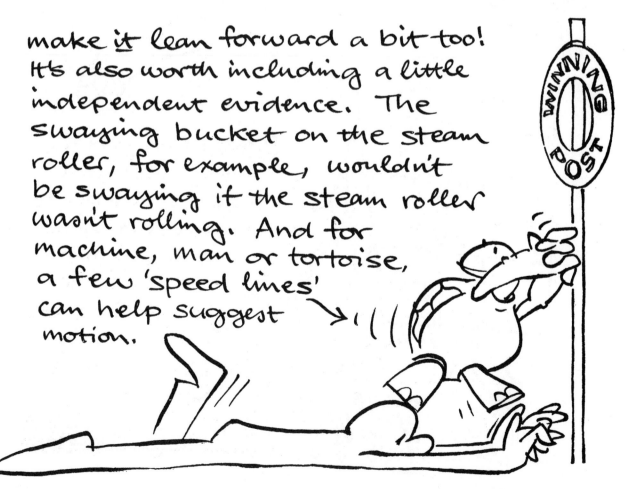

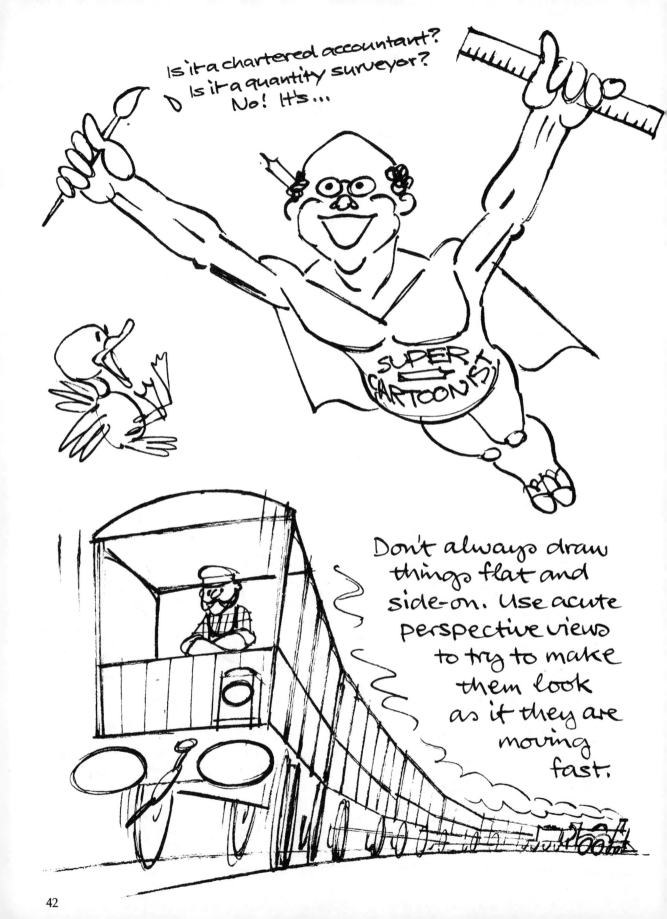

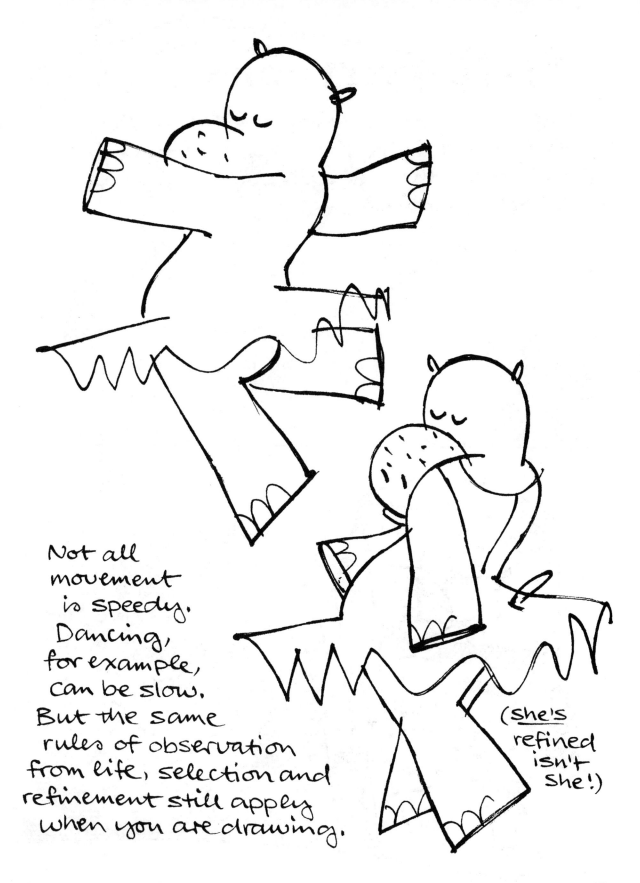

Not all movement is speedy. Dancing, for example, can be slow. But the same rules of observation from life, selection and refinement still apply when you are drawing.

(she's refined isn't she!)

Strip cartoons

There is another way to deal with movement in a cartoon, and that is to use more than one drawing - a strip cartoon in other words...

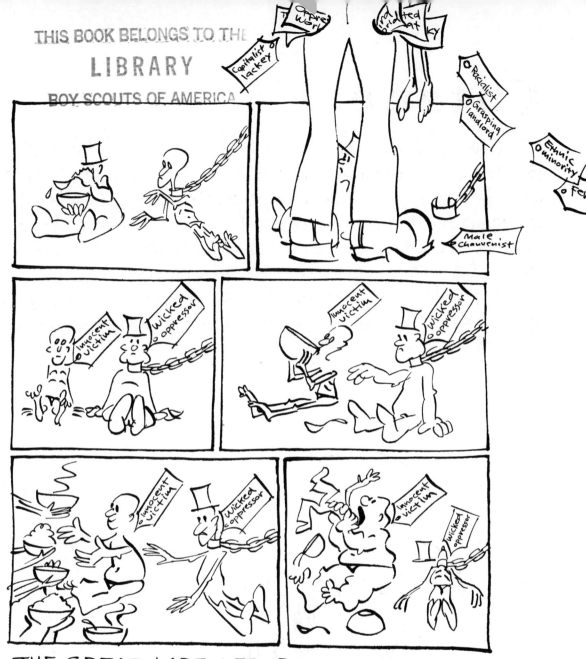

THE GREAT LABELLER PASSES

The strips can be piled one on another
as in a comic, or featured week
after week. The potential for movement
is increased astronomically, as
is the potential for character and
plot development.

Cuteness

Nature designs babies to appeal to the protective instincts of adults - or perhaps it designs the protective instincts of adults to respond to babies. Either way, if you want to draw appealing characters, you should accentuate the babyish qualities. Not just size, but large heads, domed foreheads, small noses, knock knees, turned in toes and so on.

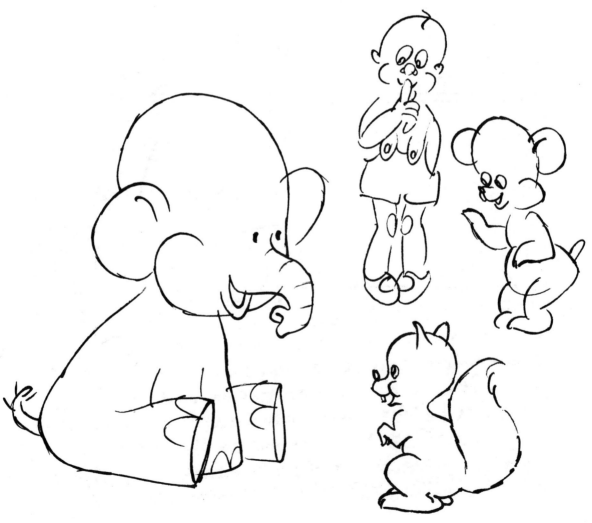

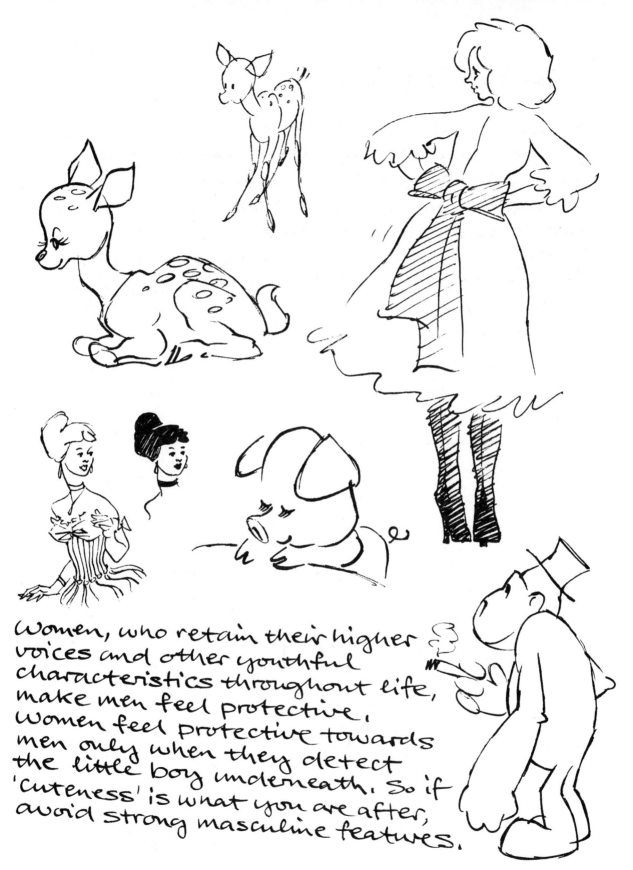

Women, who retain their higher voices and other youthful characteristics throughout life, make men feel protective. Women feel protective towards men only when they detect the little boy underneath. So if 'cuteness' is what you are after, avoid strong masculine features.

Evolving characters

Once upon a time there was a family
— Mum, Dad, a little girl called Tina,
her brother Sam, their cat and their
puppy. They lived in a children's book
that I was asked to illustrate.
I thought I'd take a child's eye level,
Mum and Dad therefore disappeared off
the top of the page from the waist
up — so that took care of them! But
as usual I sat staring at a blank sheet
of paper. It's best to get <u>something</u> down,
however wrong. At least it gives you
something to react against!
The key character was the little dog.
He ended up like this.

But before that he took many shapes. To give just one example, I thought it might be funny if the dog was bigger than the boy.

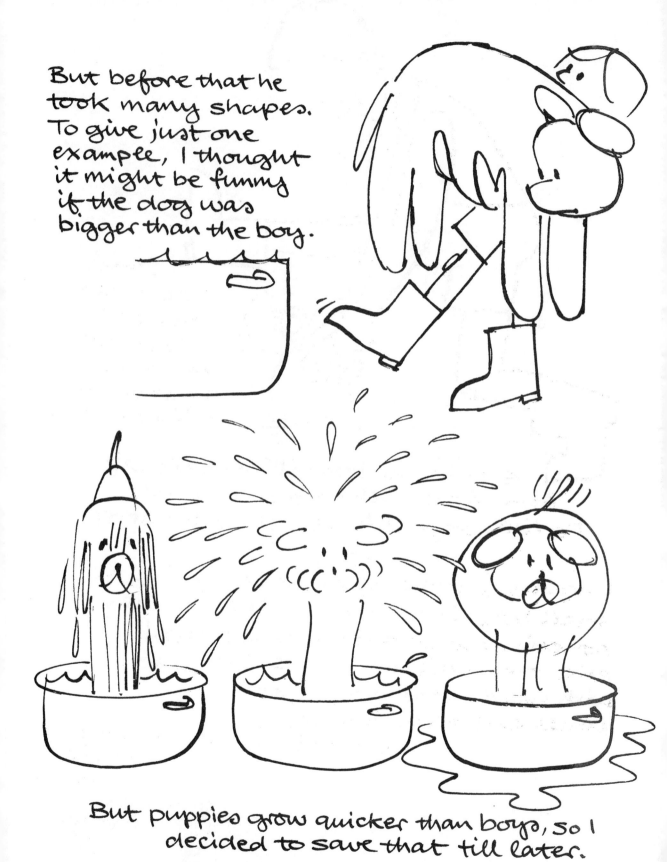

But puppies grow quicker than boys, so I decided to save that till later.

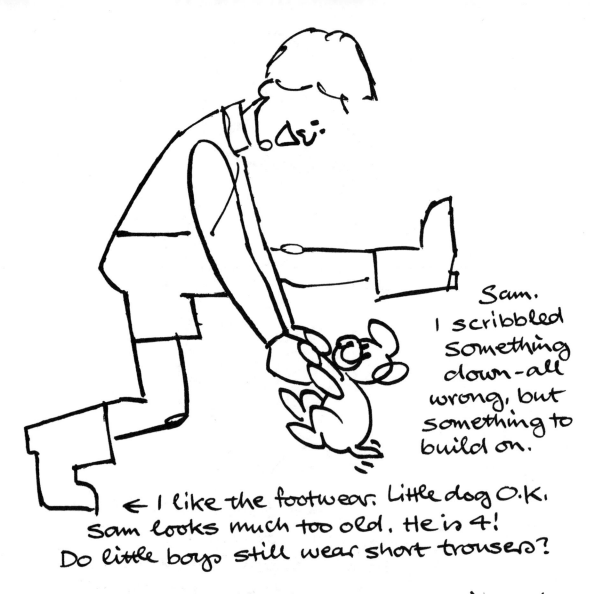

Sam.
I scribbled
something
down—all
wrong, but
something to
build on.

← I like the footwear. Little dog O.K.
Sam looks much too old. He is 4!
Do little boys still wear short trousers?

I nearly got myself arrested peering at
small boys in the street! But yes, they
sometimes wear shorts—and boots!
At 4 they have thin necks, big heads
with small noses, short, fat
limbs and tubby tummies
 like this →

having
got the
age right
I had
another
go.

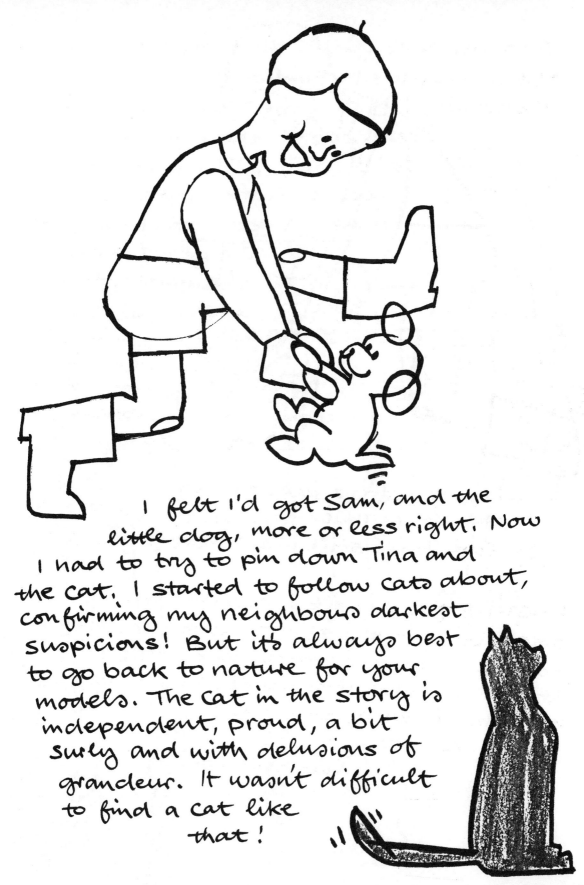

I felt I'd got Sam, and the little dog, more or less right. Now I had to try to pin down Tina and the cat. I started to follow cats about, confirming my neighbours darkest suspicions! But it's always best to go back to nature for your models. The cat in the story is independent, proud, a bit surly and with delusions of grandeur. It wasn't difficult to find a cat like that!

Tina, the little girl in the story, was 6.
Not daring to start following little girls
about too, I based the character on a
real person, the little daughter
of a friend. The portrait
doesn't flatter her, but she
made a good starting point,
The glasses and
the baggy trousers
stuck!

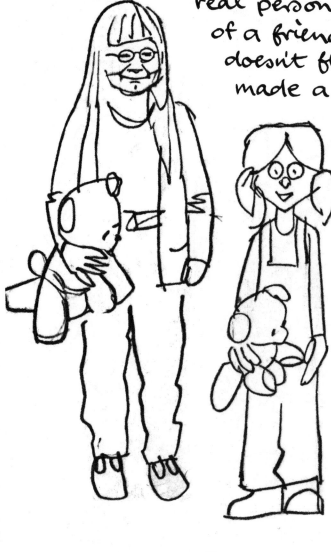

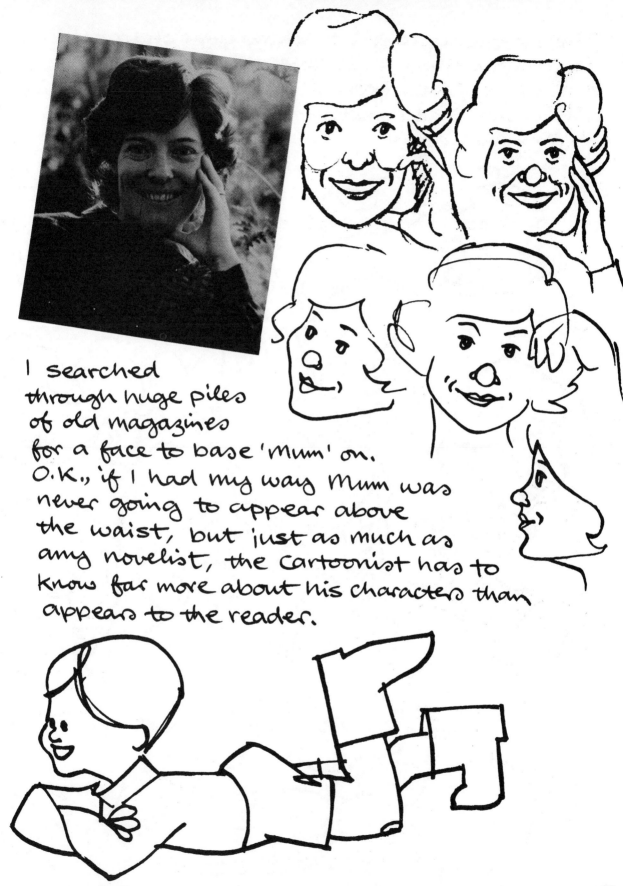

I searched
through huge piles
of old magazines
for a face to base 'Mum' on.
O.K., if I had my way Mum was
never going to appear above
the waist, but just as much as
any novelist, the cartoonist has to
know far more about his characters than
appears to the reader.

The best way to get to know your characters
is to draw them. In different poses and in
the same pose, from different angles and in
different sizes and moods. Again and
again and again...

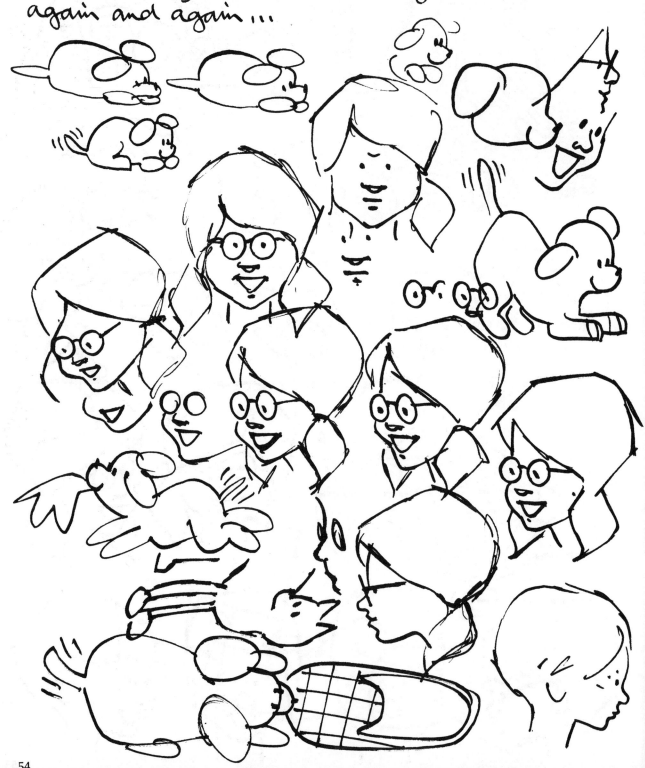

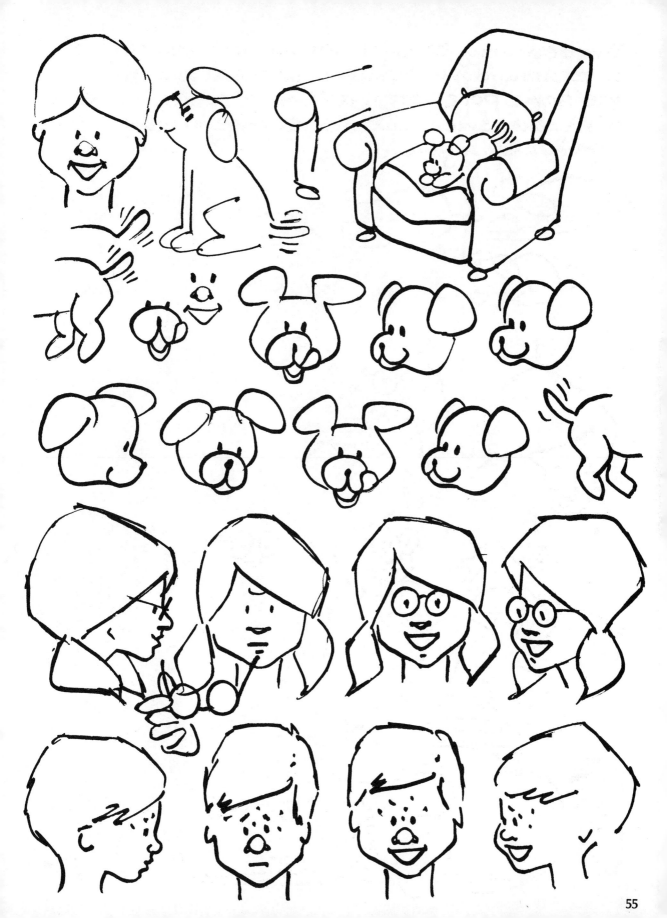

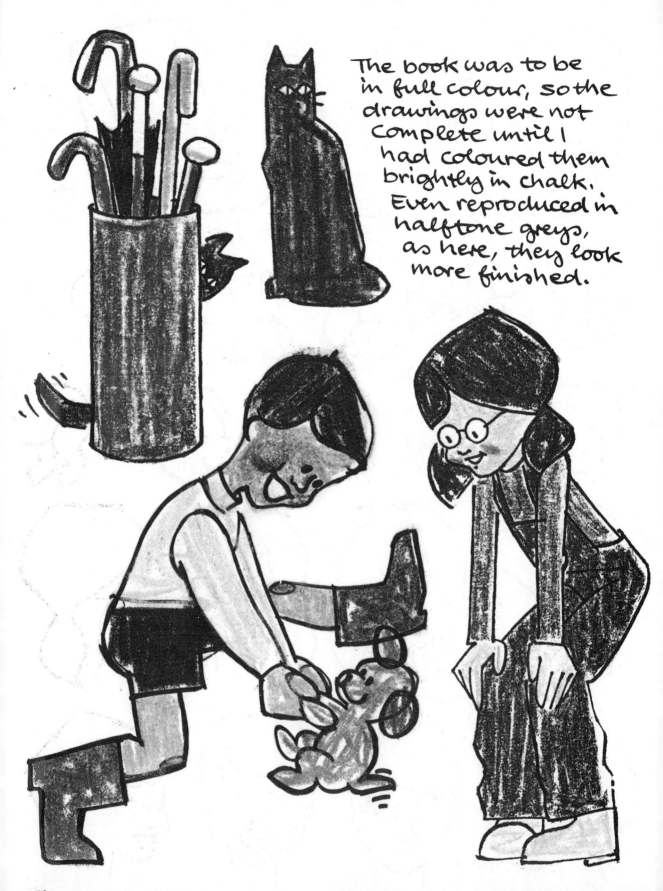

The book was to be in full colour, so the drawings were not complete until I had coloured them brightly in chalk. Even reproduced in halftone greys, as here, they look more finished.

But even halftone grey is a luxury that the cartoonist can't count on. Straight black and white is cheaper to reproduce, so straight black and white is what he usually has to work in.

This was the case when I was asked to illustrate a book of statistics. Fascinating stuff, but about as stimulating visually as a telephone directory!

I felt I needed to find a cartoon character to link the different sections of the book, (dealing with government, population, health, wealth, death, taxation and so on) plus a way to integrate my cartoons with the tables, graphs and charts used to express the facts and figures.

I decided to doodle for a bit with the sorts of statistic in the book, and tables, graphs and charts, to see if anything sparked.

United Kingdom	65.4	17.5	3.1	—	12.1	1.9	100	
Denmark	44.9	55.0	—	—		0.1	100	
France	24.1	34.6	8.3	0.3	—	7.7	25.0	100
Germany (Fed. Rep.)	56.7	10.3	20.2	1.1		7.3	4.4	100
Italy	2.9	56.2	10.4	0.6	2.3	27.6	100	
Luxembourg	0.1	15.7	49.4	0.3	—	34.5	100	
Netherlands	4.4	7.7	78.9	2.4	6.6	—	100	
Canada	13.4	4.0	4.0	0.3	5.6	72.7	100	
Japan	3.8	63.0	8.5	—	6.4	18.3	100	
USA	45.7	16.8	14.8	—	9.0	13.7	100	

I didn't get very far with tables!

Graphs

... are no joke!

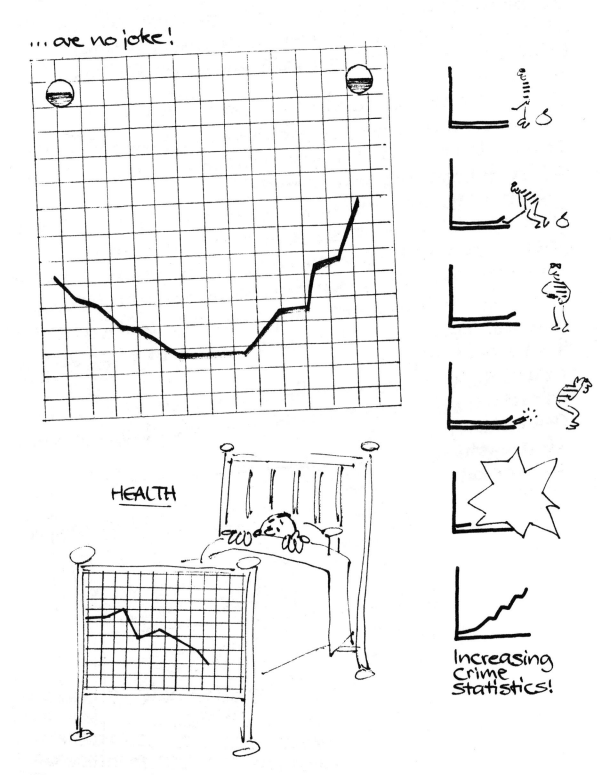

HEALTH

Increasing
Crime
Statistics!

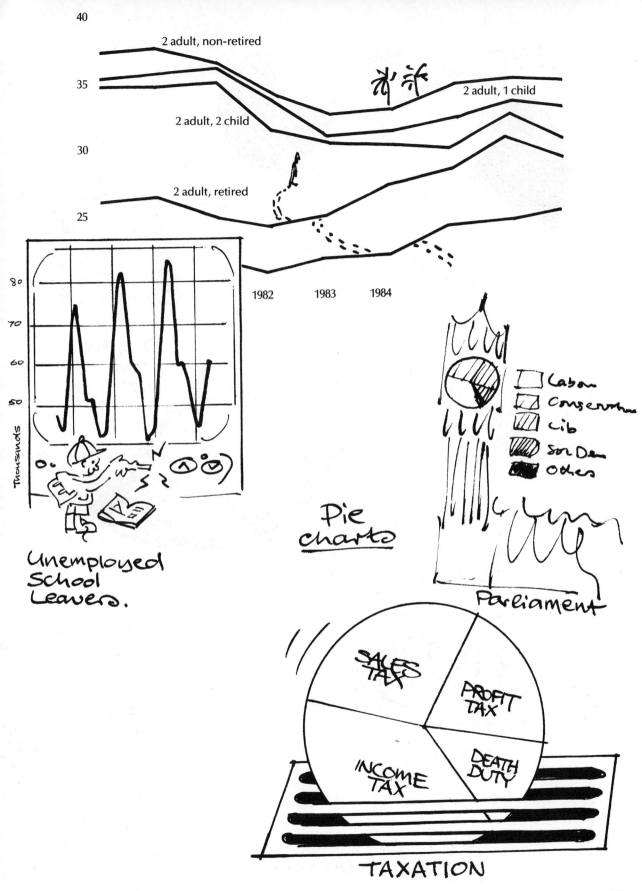

40

2 adult, non-retired

35

2 adult, 2 child

2 adult, 1 child

30

2 adult, retired

25

1982 1983 1984

Thousands

80
70
60
50

Unemployed
School
Leavers.

Pie
charts

Labour
Conservative
Lib
Soc Dem
Others

Parliament

SALES TAX

PROFIT TAX

INCOME TAX

DEATH DUTY

TAXATION

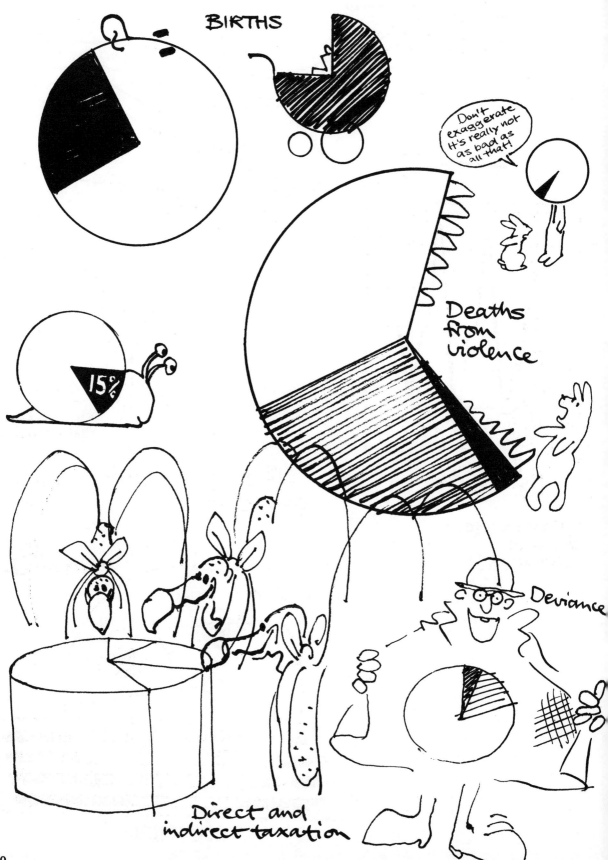

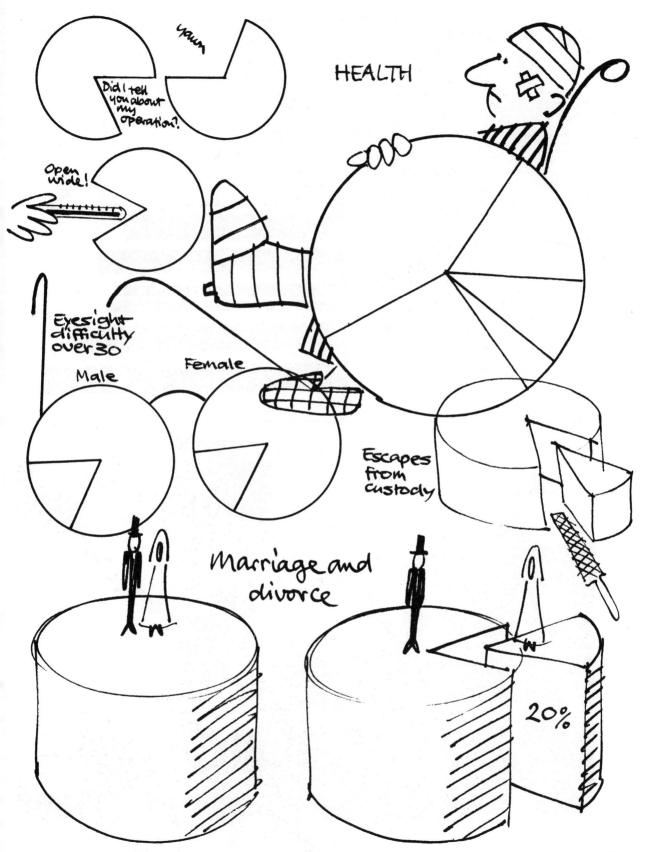

Bar charts

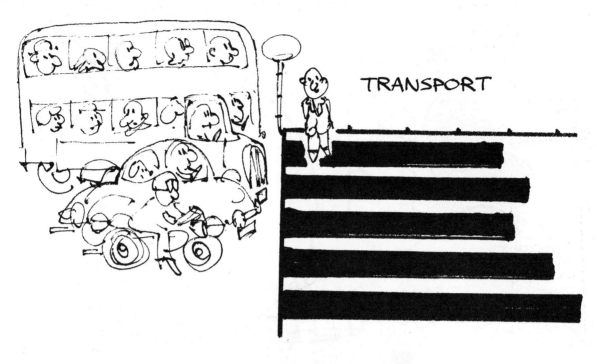

TRANSPORT

BY REGION

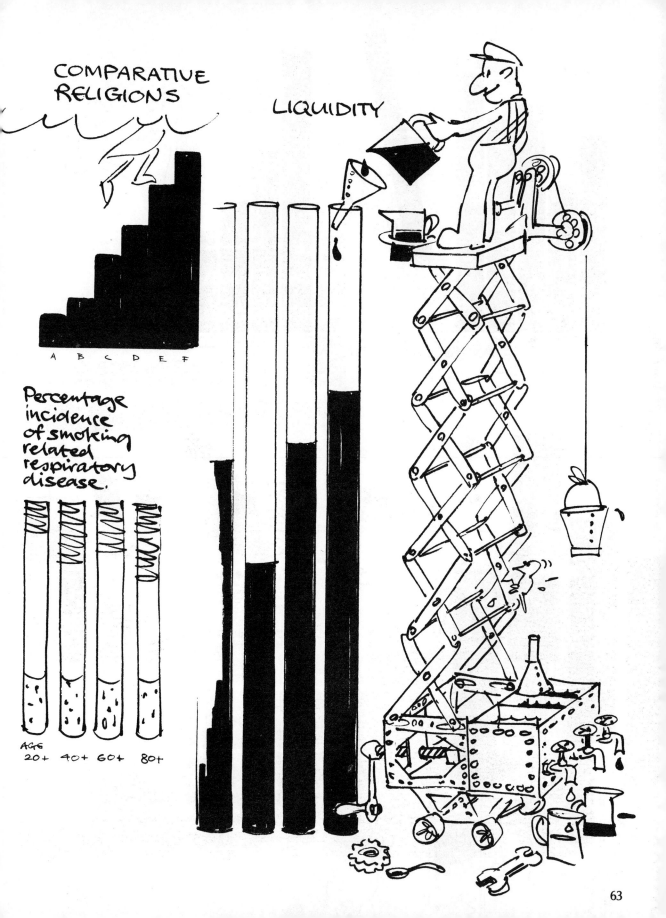

COMPARATIVE
RELIGIONS

LIQUIDITY

A B C D E F

Percentage
incidence
of smoking
related
respiratory
disease.

AGE
20+ 40+ 60+ 80+

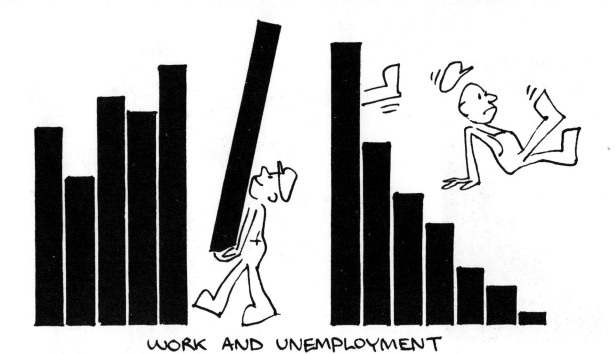

WORK AND UNEMPLOYMENT

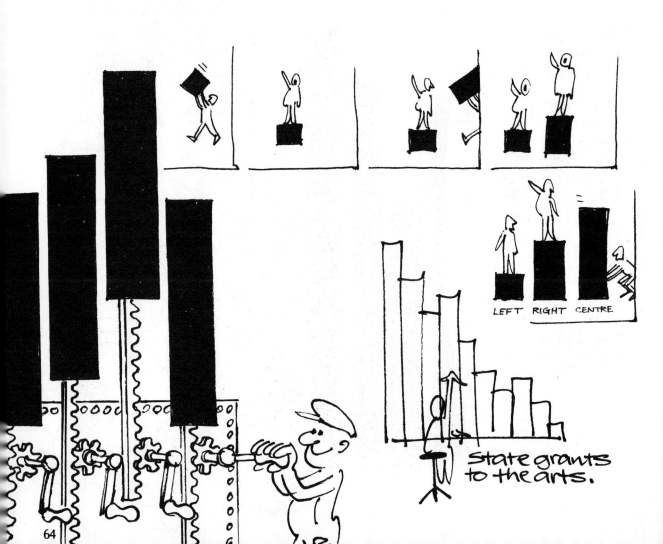

LEFT RIGHT CENTRE

State grants to the arts.

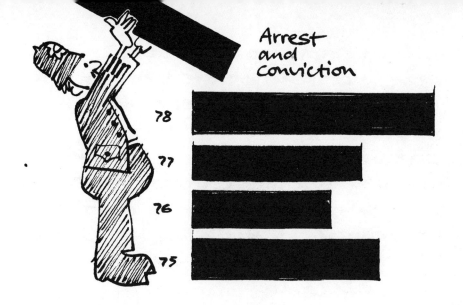

Arrest
and
conviction

78

77

76

75

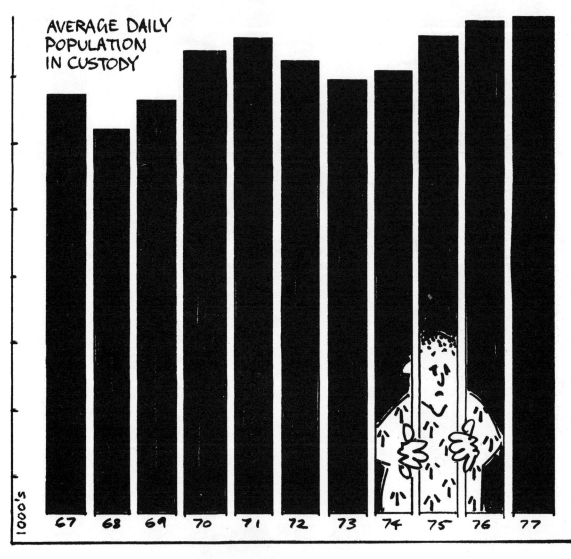

AVERAGE DAILY
POPULATION
IN CUSTODY

1000's

67 68 69 70 71 72 73 74 75 76 77

All this doodling had two results.
First, of course, I could use the best of the
ideas to illustrate the book. Secondly,
I could abandon my search for
an authoritative cartoon figure who, in
explaining things to other cartoon characters
in the book, would inoffensively do the
same for the younger or the dimmer
reader. He'd appeared
already!

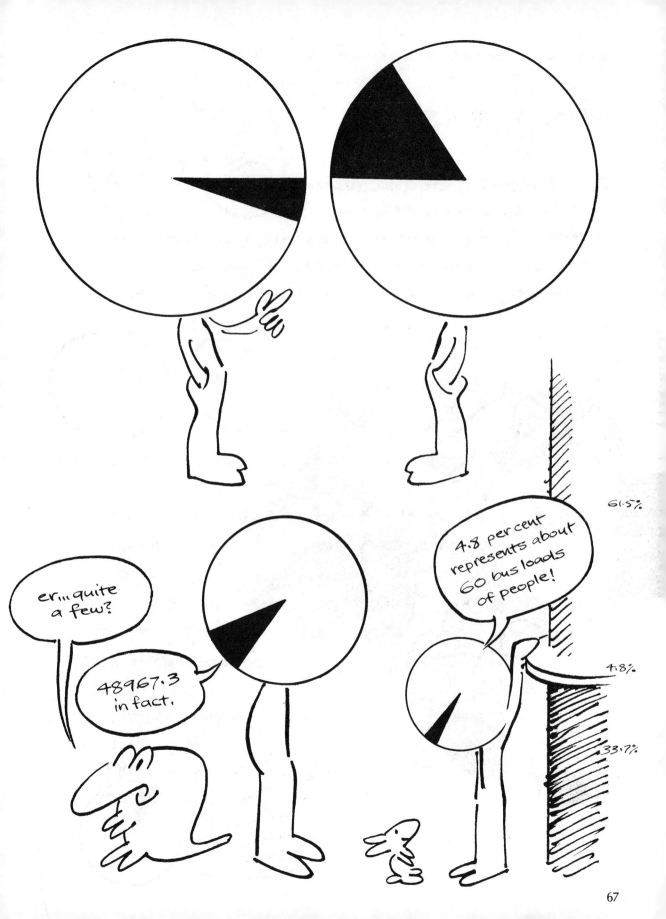

Expression

The masks of tragedy
and comedy rely on
the angle of the eyes and mouths to
suggest which is which. Eyes and
mouths are useful to indicate emotion.

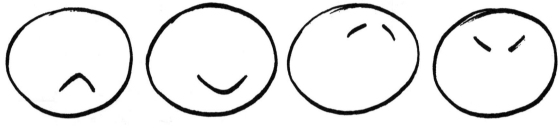

Unhappy, Happy. Unhappy. Chinese!

But it isn't quite as simple as that,
because you can combine the happy
mouth and the unhappy eyes to get a
wry grin, open the mouth wide for
a real smile, turn it
upside down for
shock or surprise,
open both
mouth and
eyes for
horror...

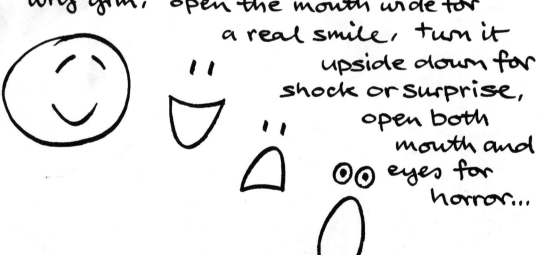

A wiggly mouth can
give a resigned expression.
So can shrugged
shoulders and
spread
hands. You
can use their
posture too, to
express the moods
of the characters
you draw.

Pride

Dejection

Relaxation

Relaxed as a newt!

If you have no
other model, act
the mood or the
emotion you want
to draw in front of a mirror to
see how best to express it.

It's worth keeping a pencil and a small pad (or the back of an envelope) handy all the time. You never know when you might see a face or an expression that you want to jot down, and waiters don't like you to draw on tablecloths!

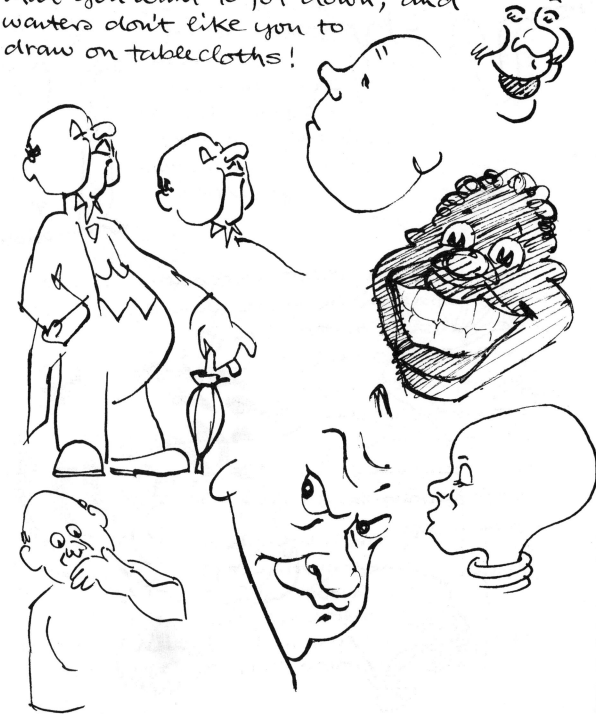

Other animals don't necessarily show their moods in the same way as us — or even as each other. A dog wagging his tail is saying something quite different to a cat twitching his. But their expressions are often only too clear!

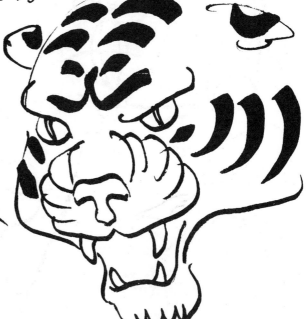

You have to look for different signals from animals. You can't lay your ears back, but a horse can - and watch out when it does! A yawning or a grinning creature might just be showing his teeth in warning, and so on. But cartoon animals are usually surrogate humans, so you can safely give them human expressions.

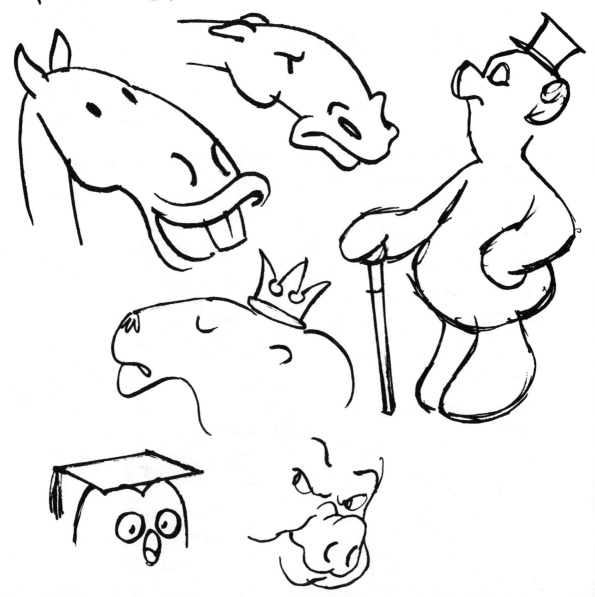

No animal has hands quite like us, and our hands are good at accentuating expressions as well as winding clocks! So it pays to study hands as well as mouths, eyes, eyebrows and foreheads...

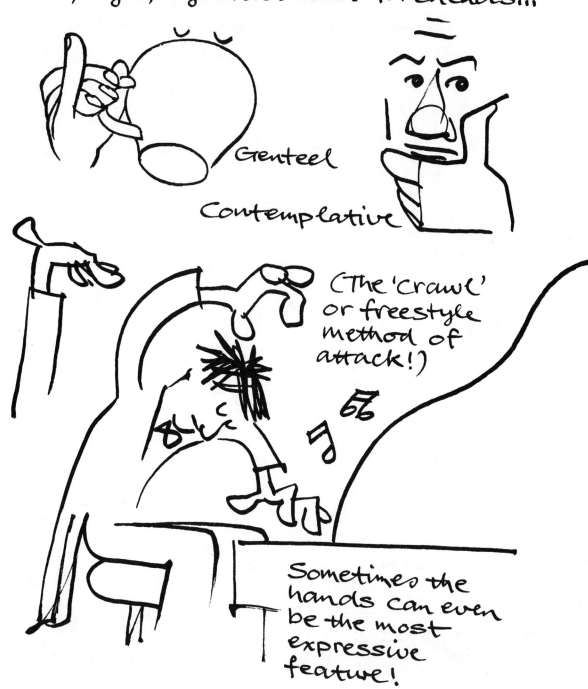

Genteel

Contemplative

(The 'crawl' or freestyle method of attack!)

Sometimes the hands can even be the most expressive feature!

Caricature

This is a caricature of a whole street!
Or, rather, of a lane. St Martin's Lane
in London, where I once worked in
an advertising agency.

The buildings are not related here as they
are in fact. Many are omitted, but the
pubs, the theatres which gave us discounts,
the cafe we favoured etc, all make it
an unmistakable portrait to my fellow
employees of that time.

I first made studies of the individual
buildings featured, then simplified
and re-combined them into my 'Lane'.

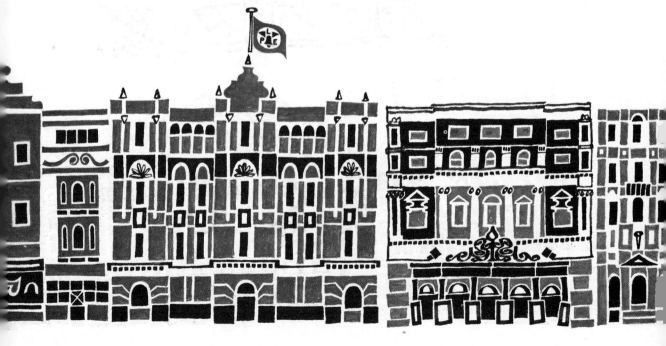

This is one of the studies →

Much the same process of making detailed studies of each feature, simplifying and re-combining them can go into drawing faces too!

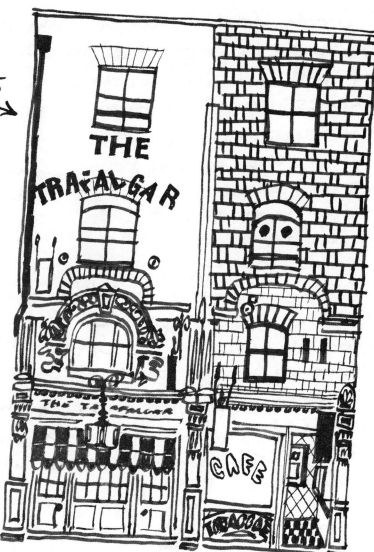

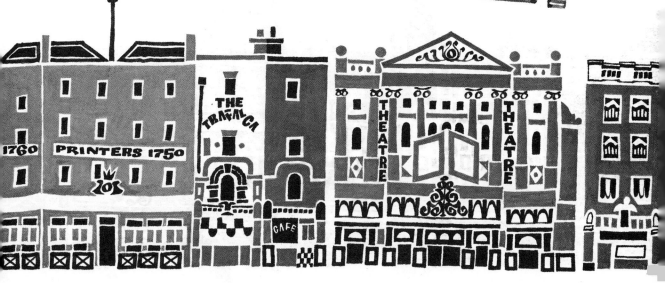

I wrote 'faces' rather than 'people' because it is the face in which recognition of the individual, as well as the expression of emotion, is centred in the human species (with many other species voice, smell or other parts of the body are more important). This is why we all look so different, and why there is a tradition in caricature drawing to shrink the body in relation to the head.

F.LAKET

N.H.P.C.C

It's worth studying individually each feature of the face you want to draw. The nose is central to most faces. Babies have almost no noses at all. Small boys have small noses. Boxers have broken noses. Romans have Roman noses. Indian braves have big noses. Arab sheiks have big Roman noses. Upper crust chinless wonders are all nose!

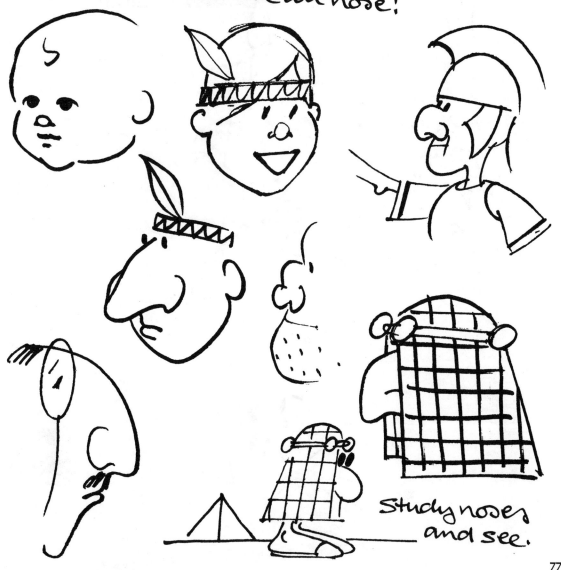

Study noses and see.

Can you close your nose under water, like a seal? Or use it to pick up buns with? Human noses aren't very mobile, so they contribute least to the expression of a face. But they contribute _most_ to its character. Variation of size and shape is incredible, nosewise. Study eyes too. It's a myth that the eyes are expressive, but the flesh round the eyes, and the way it bunches and wrinkles, can be very expressive. So can the eyebrows, and the bags underneath.

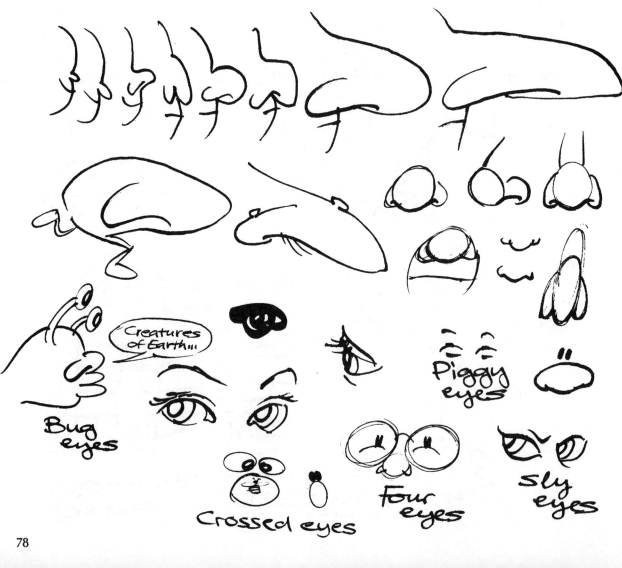

You can't have the hero gazing soulfully into the heroine's mouth, can you? But the mouth can be far more expressive than the eyes. So look into mouths too!
When you have sorted out your subject's features you can fit them all together like an Identikit portrait. But the frame you have to fit them together into is the shape of the face. Does your victim have a round or a square head, an egg head or a pear-shaped head?

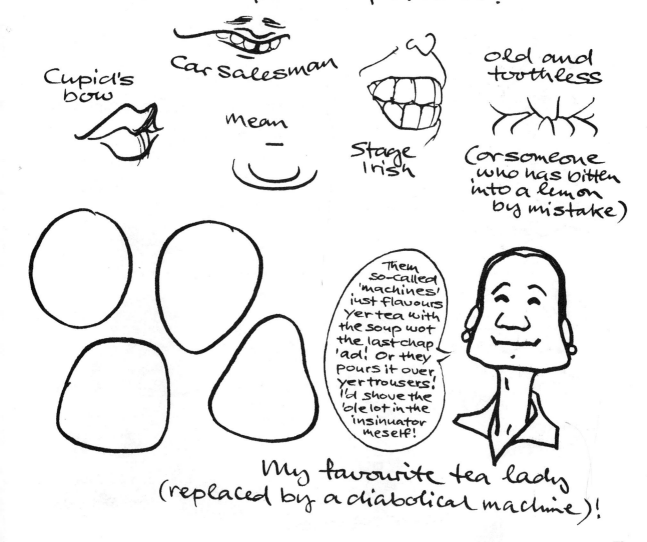

Cupid's bow

Car salesman

Mean

Stage Irish

old and toothless

(or someone who has bitten into a lemon by mistake)

Them so-called 'machines' just flavours yer tea with the soup wot the last chap 'ad! Or they pours it over yer trousers! I'd shove the 'ole lot in the insinuator meself!

My favourite tea lady (replaced by a diabolical machine)!

Do you recognise this man?
If you do you must be
about as ancient as me.
Half the people shown
the drawing thought it
was Charlie Chaplin!

Zis to be funny supposed vas?

To my mind Charlie C
is quite different (apart
from the moustache, that is).
He has curly hair under a
bowler hat, he has a cane, he has baggy
trousers and he didn't start
the Second World War.

For those who remember him,
Hitler's trade marks are
a silly moustache and his
hair combed over one eye.
So that's really about all
you have to draw.
And Charlie Chaplin too,
of course, is a gift!

It's not always so easy, but almost everyone has something the cartoonist can get hold of. De Gaulle's nose, for example, Kennedy's shock of hair, Reagan's neck... Dictators, film stars and presidents are not as accessible as tea ladies. So you have to make your studies from TV and the press.

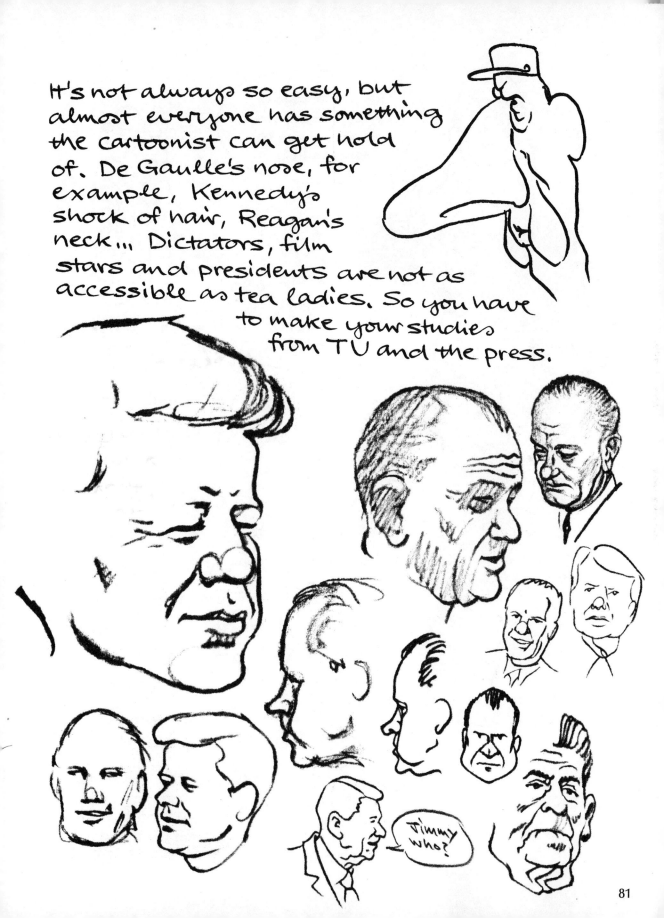

Jimmy who?

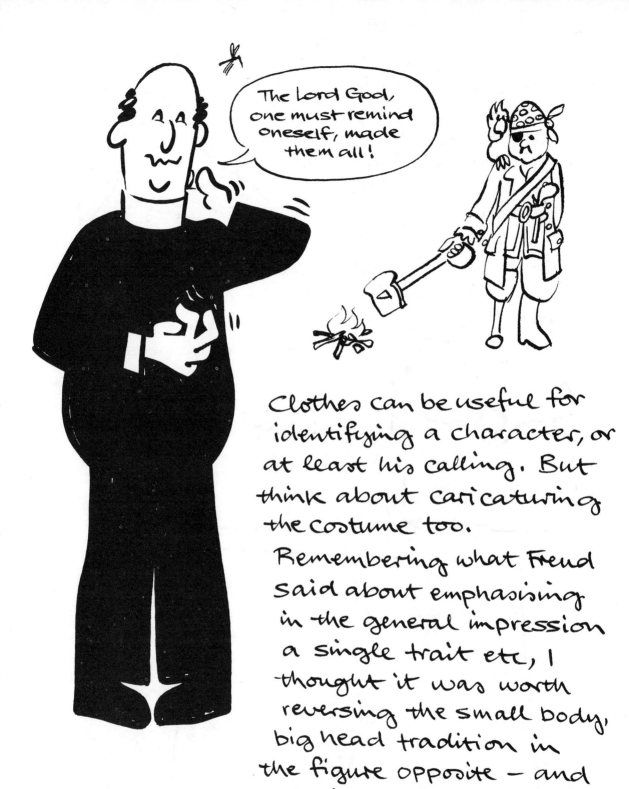

Clothes can be useful for identifying a character, or at least his calling. But think about caricaturing the costume too.

Remembering what Freud said about emphasising in the general impression a single trait etc, I thought it was worth reversing the small body, big head tradition in the figure opposite — and picking on the pockets!

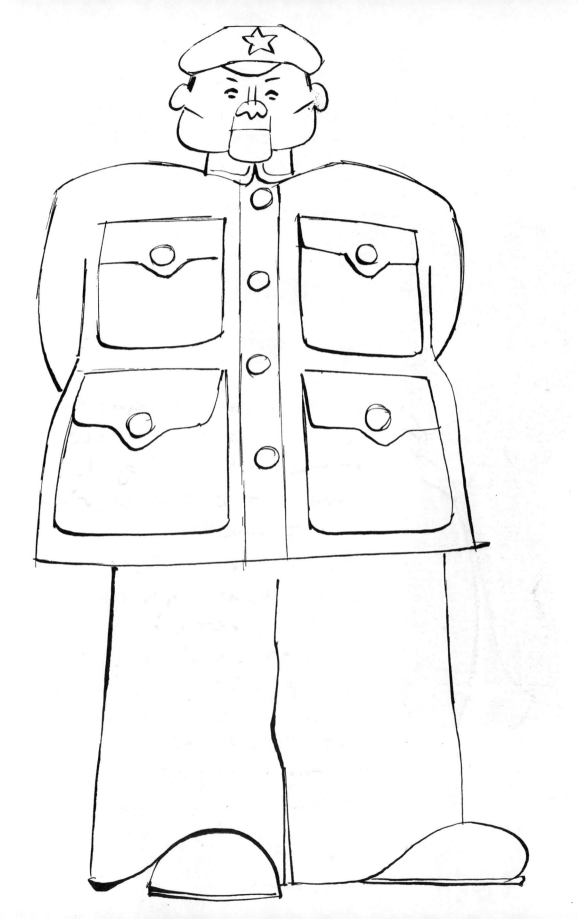

You can get a lot of cartoon costumes straight off the peg! You can get the characters inside the costumes from stock too!

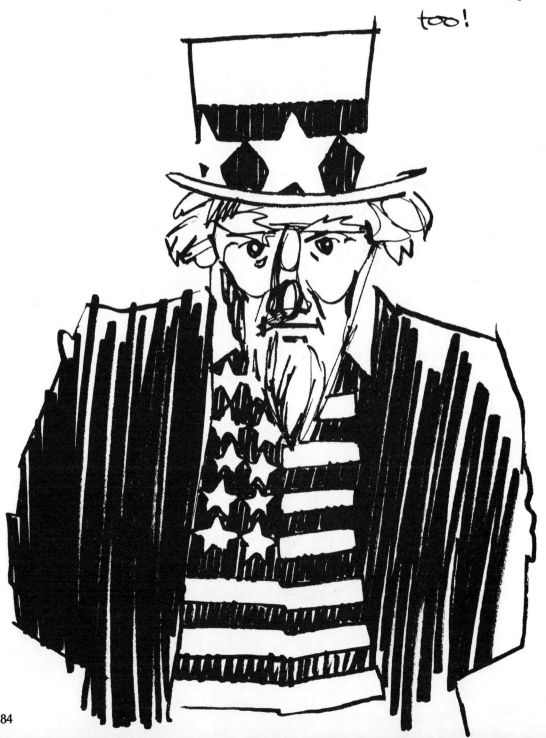

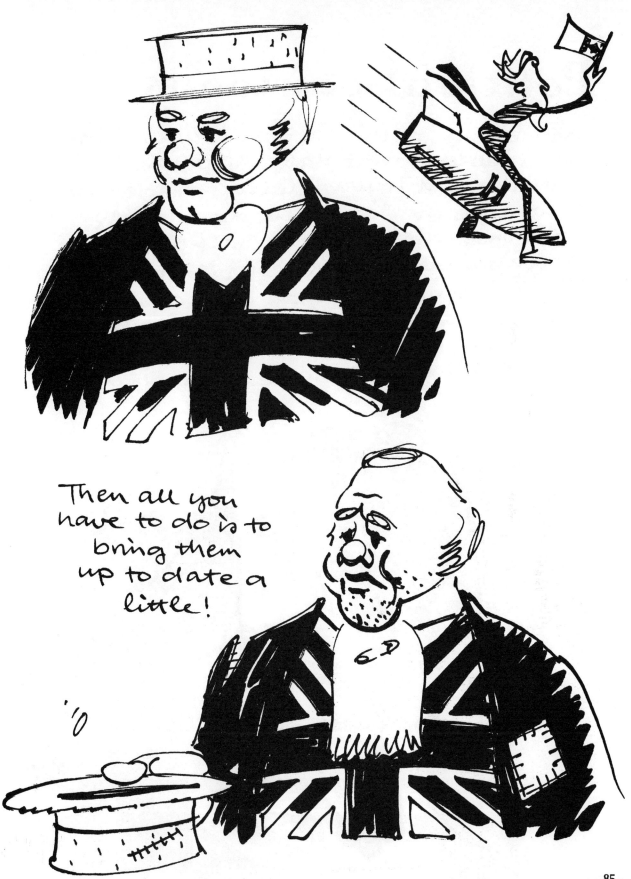

Then all you have to do is to bring them up to date a little!

Political cartoons

The message of this cartoon is quite clear. The trouble is that half the people I tried it on thought it was clearly intended to encourage the lion to lie down with the lamb, but the other half thought it was clearly intended to be ironic. If a stick has two ends it is a law of nature that someone will grab it by the sticky end. The political cartoonist has to be careful not to score an own goal!

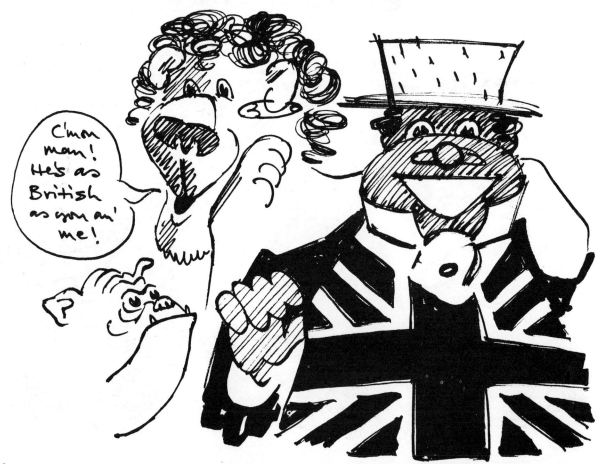

If he does so he will bring down on his head the scorn and derision of his own side. Since he is usually preaching to the converted, this is worse than merely being hated by the opposition, but the political cartoonist who is any good should expect to be loathed by about half the population. If being hated doesn't appeal to you, you could try to ingratiate yourself to all sides by picking on easy targets...

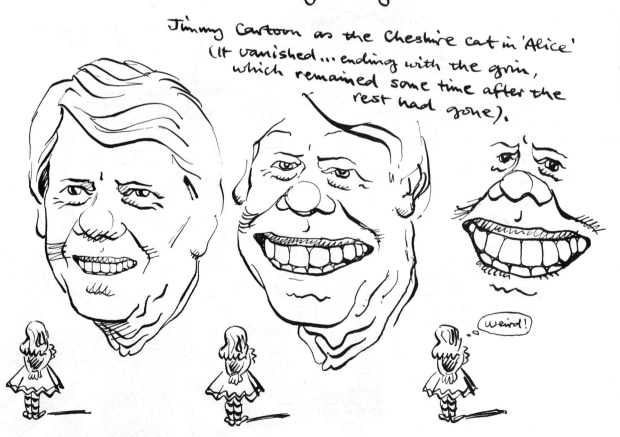

Jimmy Cartoon as the Cheshire Cat in 'Alice'
(It vanished ... ending with the grin, which remained some time after the rest had gone).

Weird!

But even that is confusing for people who fail to recognise the character you are trying to portray. We all have our weak points, and I freely admit that I don't always find it easy to get a likeness. No problem. I just label them...

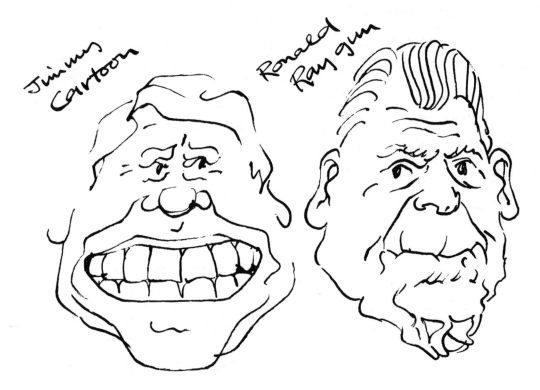

Jimmy Cartoon

Ronald Raygun

which one has teeth?

Down with EVERYTHING

The pot calls the kettle black.

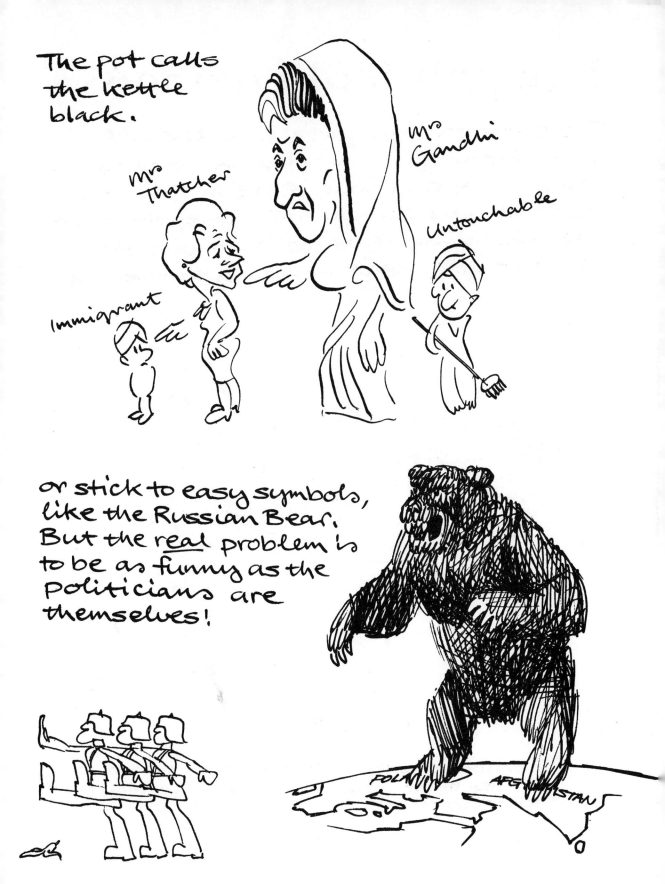

Mrs Gandhi

Mrs Thatcher

Untouchable

Immigrant

or stick to easy symbols, like the Russian Bear. But the <u>real</u> problem is to be as funny as the politicians are themselves!

POLAND AFGHANISTAN

Non-political cartoons

The scope for ambiguity is no less when your meaning is non-political. Possibly only one in any four of the people who look at your cartoon will grasp the point you are trying to make. Two will get a point you weren't intending to make at

"The trouble with these Pommie Bastards is they make abso-bloody-lutely no effort to adapt."

all! The fourth will turn over, vaguely hoping for an explanation on the next page. Only your mother will find no fault with your cartoon. Given a little luck though, they will all be amused by the drawing. And the funnier you can make your drawing, the better your chance that people will look at it long enough to get the point!

Your own unique style of drawing will help you stand out from the crowd, but it should come naturally. Seeking a personal style too consciously can make it stilted, stiff and mannered. A theme of your own can help you get established, but it might turn out to be a straight jacket, so you need to be sure you aren't going to run out of ideas.

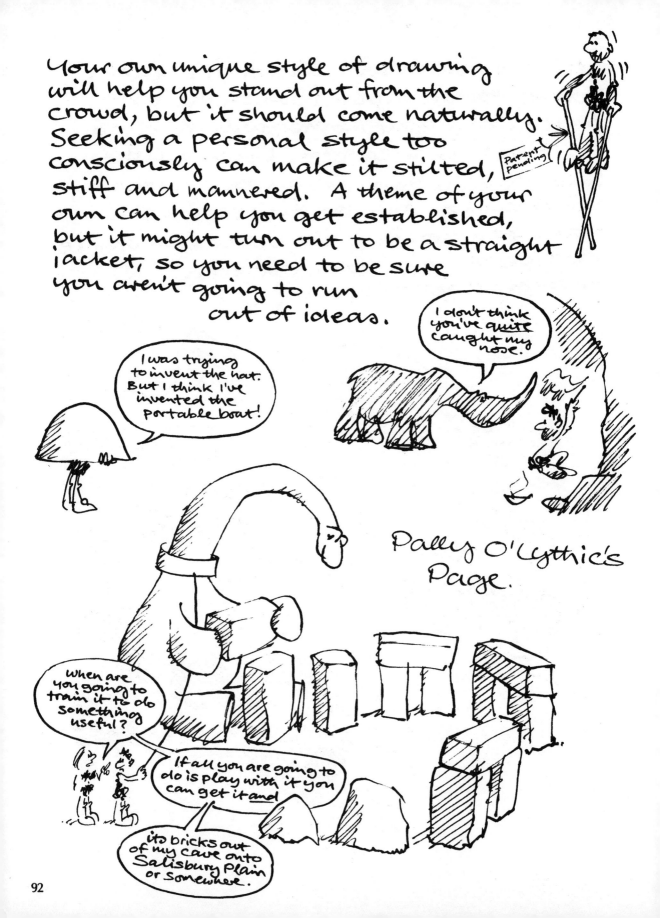

It's the idea that counts.
You can't gloss over a
poor idea with a lot of
detail. If you don't
have an idea—
you don't have a
cartoon!

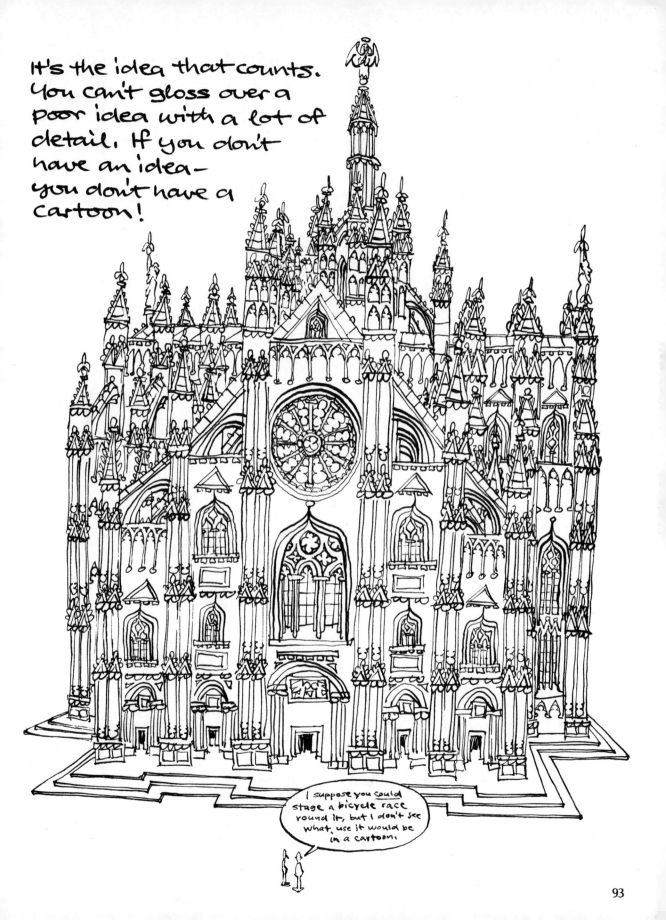

I suppose you could
stage a bicycle race
round it, but I don't see
what use it would be
in a cartoon.

Where do ideas come from? That's a tricky one, and rather beyond the scope of this book. It's good practice though, I find, to try to fit captions to newspaper photo's and advertisements.
But don't forget that not every cartoon needs a caption, and the best way I know to stimulate <u>visual</u> ideas is to doodle. If you draw freely enough you can try ideas out on other people at an early stage. More important, if you draw quickly bad ideas can spark better ideas. Aim to draw well enough to have the confidence to draw badly.

Train your hand to follow your mind's eye. And that's about it — except for the brilliant conclusion which follows...

Concl